A–Z
OF
NOTTINGHAM
PLACES - PEOPLE - HISTORY

Dave Mooney

AMBERLEY

Acknowledgements

All original photographs contained in this work are by the author. All historical images are in the public domain, except where otherwise stated.

Many thanks to Joe Earp of the Nottingham Hidden Histories team for his kind permission to use the image of Benjamin Mayo.

Dedicated to Sarah and Eleanor for their love, support and understanding in the writing of this book.

First published 2022

Amberley Publishing
The Hill, Stroud, Gloucestershire, GL5 4EP
www.amberley-books.com

British Library Cataloguing in Publication Data. A catalogue record for this book is available from the British Library.

ISBN 978 1 3981 0265 1 (print)
ISBN 978 1 3981 0266 8 (ebook)

Typesetting by SJmagic DESIGN SERVICES, India. Printed in Great Britain.

Contents

Introduction

What a lot of merits Nottingham has! What a lot of history! What wonderful people! What quixotic charm! Simplicity, hubris and global connections – this place really has got it all.

And I have had the honour of being asked to write a book about this fair city.

The volume that you are currently reading is part of a series, published by Amberley, that highlights interesting events, people and places within different British towns and cities. The only stricture provided by the brief is that the articles must form an alphabet – there must be at least one for every letter.

Something connected with Nottingham that begins with a 'Z', or a 'Q'?

'X' is easy enough, but 'Q'?

Actually, as it turned out, the possibilities were endless and I had to be quite selective about the things that I chose to write about.

Having already written two books on the city and the surrounding area – *Nottingham Pubs* and *50 Gems of Nottinghamshire* – I have endeavoured to avoid repetition. If you are wondering why Bendigo Thompson, Ye Olde Trip to Jerusalem and Greene's Windmill are not here, then I would advise you seek out my earlier works. Where I have revisited a subject, I have tried to do so in a different and interesting way.

In previous books, I have done my best to avoid the obvious, and to some extent I have carried on in that vein. Nottingham Castle is still not included. I have finally got round to tackling the subject of Robin Hood, although only because I feel that – perhaps uniquely – I have something new to add to the subject.

As the book started to take shape, I came to realise several things. Firstly, I noticed that I wasn't just writing about the city – I was writing about the world. From Soviet labour camps in Siberia, to folk singers in the Appalachian Mountains of Kentucky; from the musical compositions of a French-Lebanese organist, to the humanity of a king on the South African Veldt – Nottingham is a place that has influenced the world and that the world has, in turn, shaped in its own image.

Secondly, a very definite and distinct culture began to reveal itself. It is obvious that something can be 'very Nottingham': gritty, daft, slightly sentimental and saccharine, and with a subtly rebellious edge. This is the kind of town that elevates the mushy pea to the position of a local delicacy and sends Paper Lace to the top of the hit parade. Here, the local heroes randomly bash upon brightly coloured children's instruments, or lead armies of schoolboys to attack the castle. There have been many attempts to give the city a, faintly ludicrous, sense of grandeur or – even worse – to characterise it as cool, hip and 'up and coming'. Thankfully, it is none of these things. To misquote Monty Python, Nottingham is a silly place.

Thirdly, it became obvious that the city seemed to reach some kind of cultural peak in the 1980s. This was the golden era of Central Television, Torvill and Dean, Nottingham Forest and Su Pollard. Perhaps it is only nostalgia for my own childhood that has created this illusion and, if so, I apologise, although I think not. For some reason, for a brief period, Nottingham swung like a pendulum do.

But enough of this prattling. Without further ado, I lay before you an alphabetised introduction to the city – warts and all.

Albert Hall

Impressive as Nottingham's Albert Hall is, I still find myself viewing it with a degree of sadness. Initially envisioned as a Temperance Hall by those bastions of high Victorian sobriety the Good Templars, the original building was designed by the city's favourite architect, Watson Fothergill. Old photographs show an imposing, almost ecclesiastical, looking edifice in his inimitable style. Sadly, this incarnation was not to last. It was destroyed by fire in 1906.

A sorry tale, but the Albert Hall that we now have is not without its own, considerable, charms.

The replacement building, this time built for use by the Methodist Mission, was done in the style of a large neoclassical theatre. It was used as a space for large meetings and performances – a function that it still holds today. As well as hosting corporate events, Christmas parties and concerts, it is also used as an exam hall by the local university and regularly appears as a venue for both the BBC's *Question Time* and *Songs of Praise*.

The Main Hall is a large airy space with tiered seating on three sides and a large parquet floor. The ceiling which arches over it contains huge roundel windows and is decorated with beautiful tracery. It gives one the impression of standing inside a giant and very expensive wedding cake.

The dominating feature of the room, however, is the prodigious organ which stands at one end. This was built by the famous organ maker J. J. Binns, of Leeds, in 1909. It was gifted to the city by none other than Jesse Boot (of the famous chain of high street chemists). When he was a youngster, he had heard an organ recital in Liverpool and, being much moved, he had vowed that, should he ever become wealthy enough, he would buy one for the people of Nottingham. He was as good as his word.

To mark the centenary of the organ's instillation, the French-Lebanese composer Naji Hakim was commissioned to write a piece. His 'Fanfare for Nottingham' is a joyful affair that riffs on a hymn tune, once attributed to Mozart.

Should you ever find yourself in the Albert Hall, at a tedious, corporate event, or sitting an exam that requires answers that you simply do not hold, why not look up for a moment at the majestic organ, with its robust woodwork and rigid armies of pipes, and imagine for a while the wonderful music that you could be listening to instead.

Of course, Binn's Organ was not Jesse Boot's only gift to the city ...

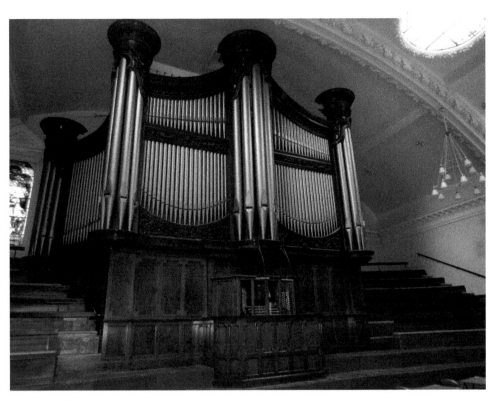

The majestic Binns Organ.

Clear blue skies over the Albert Hall.

Boot, Jesse

Ah, the halcyon days of my youth – what would they have been without the occasional amble around the boating lake at Highfields Park. On a summer's afternoon, students from the adjacent University of Nottingham campus take to the water. The lake is picturesque, surrounded as it is by weeping willows and crossed by romantic-looking bridges. A strong oarsman might, in their allotted time, reach the far end, where stepping stones and a cascade provide a suitably soothing backdrop to the gentle exertions of the rower's art.

Elsewhere in the park, there is a play area for the children, complete with sandpit and an array of unusual and interesting play equipment. (I particularly like the tubular bells.) There are waterfowl aplenty, and an arts centre with adjoining cafe and facilities to play croquet, crown green bowls and crazy golf. There is also, usually, an ice cream van parked up and ready to provide refreshments.

The idyllic boating lake at Highfields.

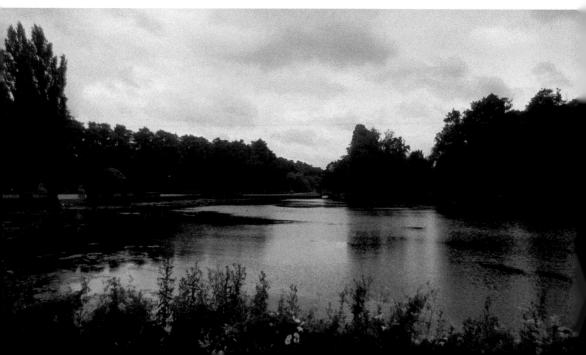

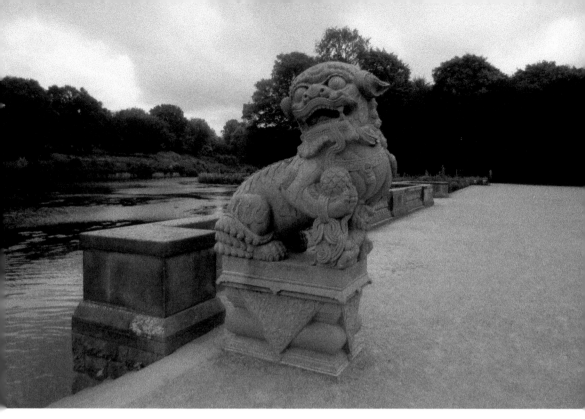

Above: A Chinese temple dog reflects the international connections of Nottingham University.

Below: The university's iconic Trent Building, as viewed over the lake.

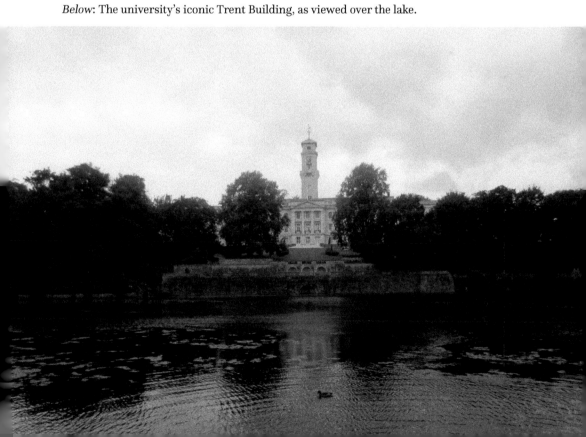

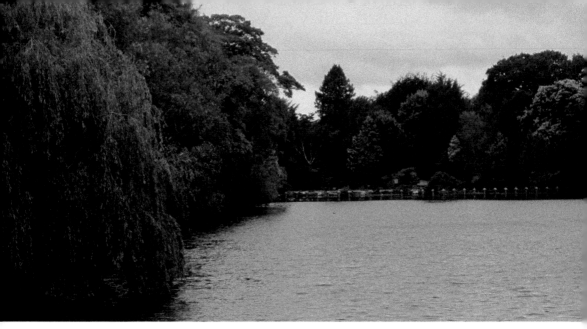

Above: Weeping willows at Highfields.

Left: Benefactor, patron and chemist – Jesse Boot.

This other Eden was gifted to the people of Nottingham by Jesse Boot (1850–1931). Having built up his late father's company and made a tidy fortune in the process, he decided to construct a model village for his workers (in the mould of Bournville or Port Sunlight). He bought the land but, having sold the company, the project never came to fruition. Instead, much of the Highfields estate was donated to the city council. Playing fields were built, as was the largest lido in the country. The area immediately to the north of the present-day park was also donated, as a campus for the new University College.

His generosity did not end there, and many examples of his charity can still be found around the city (*see* Albert Hall). For his exceptional works, he was elevated to the peerage, becoming the first Baron Trent.

One can only hope that the more recent – less than ethical – activities of the company that he nurtured have not managed to sully the name of one of Nottingham's great patrons.

Brown Sauce

There are many comestibles that are synonymous with the place where they were originally created: Melton Mowbury pork pies, Stilton cheese, chicken Kiev and, of course, champagne. It is, of course, a universally recognised truth that all of the above can be greatly improved by adding a dash of HP brown sauce.

The origins of brown sauce are very ancient indeed, with its direct antecedents, such as rapey or civey sauce, being traceable back as far as, at least, the fourteenth century. Brown sauce proper, however, didn't really come into existence until the middle of the nineteenth century. It wasn't until the 1890s that the nation's most iconic brand was launched. In 1895 a grocer from Basford, Fredrick Gibson Garton, developed a recipe for the tangy, tamarind-based condiment. A culinary star was born and it soon became a staple favourite across the country. When Garton heard that it was being used in a restaurant within the Houses of Parliament he decided to christen it HP Sauce. To this day, the label on the bottles still shows a picture of the Palace of Westminster.

Inevitably, the brand has not stayed local – it is owned by Heinz and is manufactured in the Netherlands – but it is still gratifying to know that the most iconic accompaniment to all of our breakfasts was first made in Nottingham.

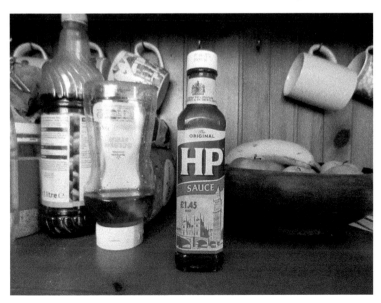

Is there anything that it doesn't go with?

Caves

Both literally and figuratively, Nottingham's identity is built upon a bedrock of red Triassic sandstone.

This rock was laid down around 250 million years ago, on the cusp of the Permian and Triassic eras, when the area that we now call Nottingham was located far to the south of its current location, beneath a shallow sea.

At the time, the weird, prehistoric animals that populated the Earth were dealing with a mass extinction event. Distracted as they were, it is doubtful whether any of them ever speculated about the future impact of sedimentation upon Nottingham's pub trade.

Zooming forward through time, at breakneck speed, we arrive in the ninth century. Here, we find a Welsh monk by the name of Asser, working on a biography of Alfred the Great. His *Life of King Alfred* was almost certainly composed for a Welsh audience, unfamiliar with obscure English places. He named Nottingham 'Tiggou Cobauc', in the Old Brythonic tongue that his readership would understand. Rather poetically, it might be translated as the 'Place of Caves'.

The Saxon people of Snottingham (as it was then called in English) were making good use of the sedimentary rock upon which their settlement was built. The sandstone could be easily carved, which makes it perfect for excavating caves. These may be used for any number of purposes – from tanneries, to maltings, to dwellings.

And they were.

The city is built upon a honeycomb of man-made caves. Over 850 are known about and many of them are still in use today. Various visitor attractions – City of Caves, Brewhouse Yard, Nottingham Castle – are built around (or at the very least include) subterranean spaces. Elsewhere, pubs such as Ye Olde Trip to Jerusalem and The Hand in Heart are partly cut out of the rock. Many other pubs dotted around the city have caves that are used as cellars, and they often allow for visitors or use them to host themed events.

Cave entrances can be spotted in places such as the Rock Cemetery, the Sneinton Hermitage, and at Hollowstone, near St Mary's Church in the Lace Market. These are gated off to prevent misuse and danger to the public, but they present an enticing prospect to adventurous passers by.

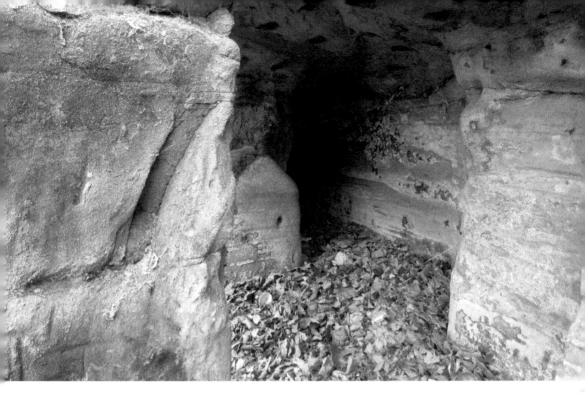

Above: Caves under the castle.

Below: Urban troglodytes.

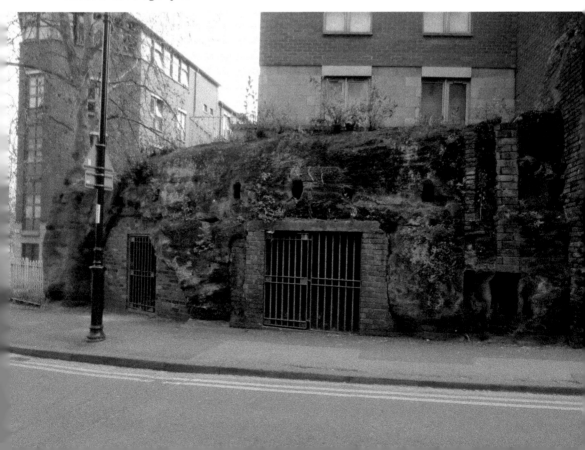

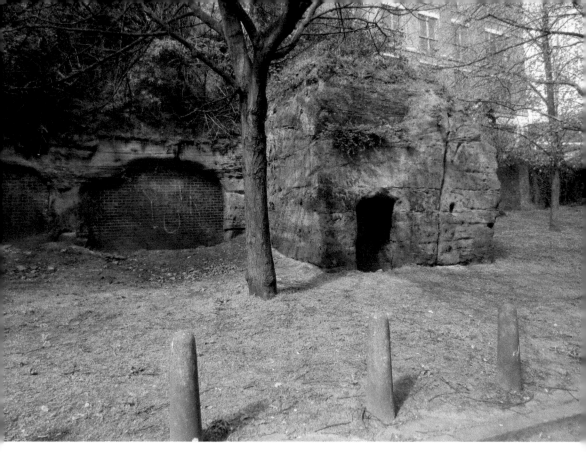

Bollards and graffiti in the 'City of Caves'.

For many centuries the caves were, of course, used as accommodation. There are no longer any official troglodytes, but as recently as 2018 members of the city's homeless population were found living underground.

With more man-made caves than any other city in Europe, Nottingham is truly a *Tiggou Cobauc*!

Coates, Eric

Never heard of him? You'll know his music.

Like most people in Britain, I spend an inordinate amount of time figuring out what my *Desert Island Discs* are going to be, should the BBC ever be inclined to ask.

The radio programme is based around the concept of a guest celebrity/notable being stranded on a remote island. They are allowed to take with them a luxury item, the *Bible*, *The Complete Works of Shakespeare*, a book of their choice and eight records. The format is obviously a good one as the show has been running, pretty much unaltered, since 1942.

For almost eighty years, the familiar, iconic, theme tune has been heralding the start of another castaway's choices. It is a lazy, rolling piece of music, entitled *By the*

Sleepy Lagoon. It conjurers up images of gently lapping waves, sun-drenched white sand and the calling of gulls. No *Robinson Crusoe* ordeal this; this is a blissful exile in paradise. A break from the hectic, cut and thrust of the civilised world.

By the Sleepy Lagoon was written in 1930 by Eric Coates (1886–1957), a composer from the small former mining town of Hucknall, just outside of Nottingham. He achieved some popularity in the interwar years with a number of jaunty, melodic, light pieces. Coates' work tends to have a good rhythm and a tune that you can hum.

They make perfect theme tunes.

His busy, industrious piece *Calling All Workers* helped many a factory girl and mechanic through their daily grind as, for twenty-seven years, it was the theme to *Music While You Work.* It is still used today as a shorthand by those wishing to evoke the mid-twentieth-century working class. Undoubtedly though, Coates' most iconic contribution to our national music came in the form of his theme for the 1955 film *The Dam Busters.*

Actually composed slightly before he was commissioned to write a piece for the film, *The Dam Busters March* is stirring, slightly jingoistic and deliberately Elgaresque. It is fused in the national consciousness with both the film and the real-life events – Operation Chastise – that inspired it. It is a staple at any event that celebrates Britain's victory in the Second World War, or her general military prowess.

Love it or loath it, Coates' music exists in all of our minds as the soundtrack to a certain era in our nation's history, and a certain, very confident, kind of Britishness.

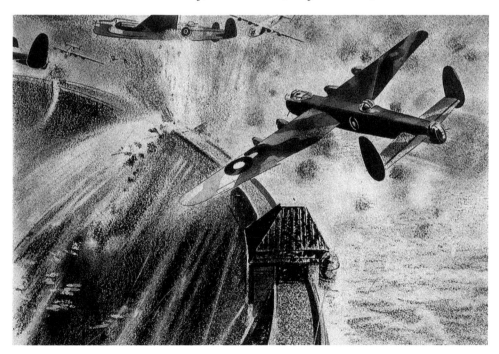

A contemporary drawing of the 'Dam Busters'.

COVID-19

When putting this book together, I had planned to have all of the writing completed one month ahead of the deadline. The remaining time I would use for going around the city, taking photographs.

Ah, the best laid schemes o' mice an' men, gang aft a-gley!

Unfortunately, the month that I had allotted for taking photos was April 2020, which – as we all know – turned out to be the height of the COVID-19 prevention measures. Undaunted, I did take a trip into town, on my push bike, to try and get some snaps. The city centre was eerily deserted.

Whilst a lot of what I took that day was unusable, as I dashed about, frantically trying to get the shots that I needed, I did manage to get some striking images from a very specific point in the city's (and the world's) history.

For your delectation, here are a few of the most striking.

An empty city.

Lockdown Nottingham.

Above: Deserted streets during the height of the global pandemic.

Below: A rainbow of hope and gratitude to the NHS.

Dome

Nottingham's skyline is dominated by the huge dome atop the Council House. In many ways, alongside the statue of Robin Hood, it has become the emblem of the city.

The Council House stands – a titanic, grey-white, neo-Baroque edifice – at the heart of the city. It looms over the Old Market Square and dominates the wide, pedestrianised areas that flank it. It seems impossible that this building hasn't been there since time immemorial – a naturally occurring phenomena, beyond the ability of man to

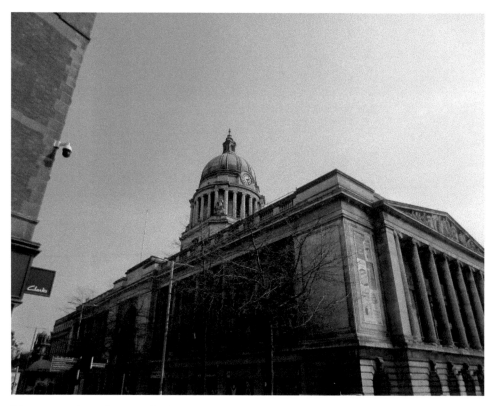

It's more modern than you think.

construct. A look at old photographs, however, shows that it is of surprisingly modern provenance. The dome was built, along with the rest of the structure, in the late 1920s.

Prior to its demolition in 1926, the grand – and yet not so grand as its replacement – Nottingham Exchange occupied the same site. With a pointed roof and clean lines, the older building lacked both the majesty and the dome of its successor.

The dome, which is not dissimilar to the more famous one belonging to St Paul's Cathedral, is 200 feet high. Four statues, each created by a different sculptor, stand around its base, representing commerce, prosperity, civic law and knowledge. These may be the philosophical pillars of urban civilisation, but more literal pillars are also in evidence. Between these, large, illuminated clock faces keep time for the local populace. Chimes that can be heard across the city sound each quarter of an hour, and an enormous bell – suitably titled 'Little John' – marks the hours with a sonorous Eb. This is deeper than Big Ben and carries over a much greater distance. In the right conditions Little John can be heard up to 7 miles away!

In fact, Little John was in the running to be a temporary replacement for Big Ben on Radio 4, whilst the more well-known bell was being repaired. However, it proved unsuitable as it does not chime at midnight.

Of course, the dome has an inside as well as an outside, and that is best viewed from the Exchange Arcade.

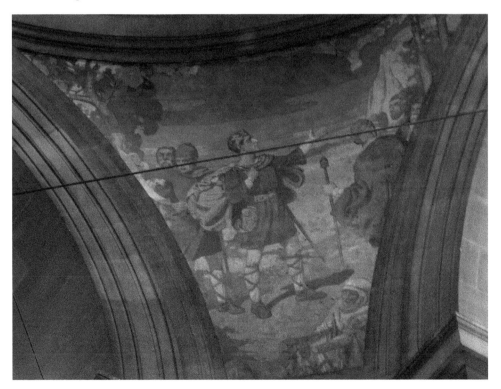

The Dome's interior murals: William I giving out orders.

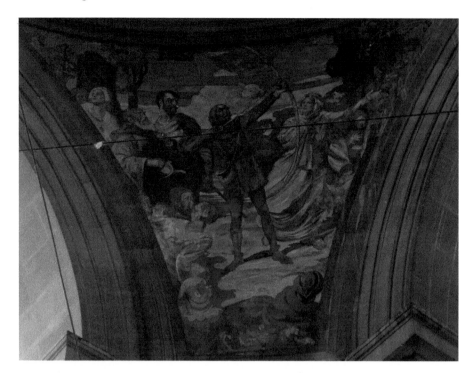

Bold Robin Hood.

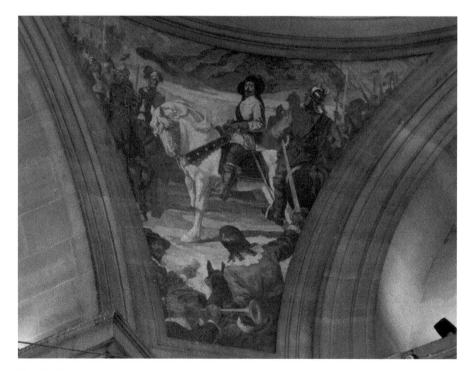

Charles I.

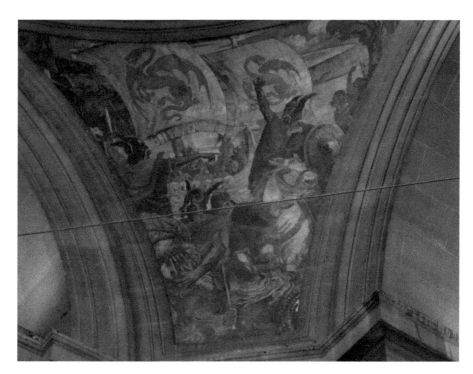

The Danes – in very impractical helmets.

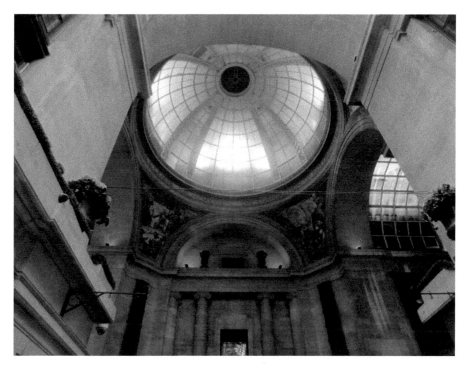

The beautiful interior of the dome.

Exchange Arcade

I know that I often bang on about it, but I really don't like indoor shopping centres. Retail depresses me, but even I have to admit that the Exchange Arcade has a touch of class. Situated at the back of the Council House, 'The Exchange', as it has now been re-branded, is home to a number of high-end outlets. Here you can buy expensive, well-made clothes and artwork painted by celebrities. There is a lovely tobacconists at one end of the T-shaped arcade that smells divine and does a fine line in snuff, cigars, single malt and carved walking canes.

The 'Exchange'.

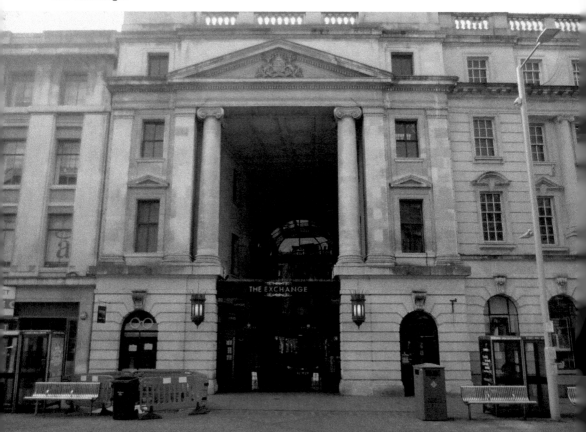

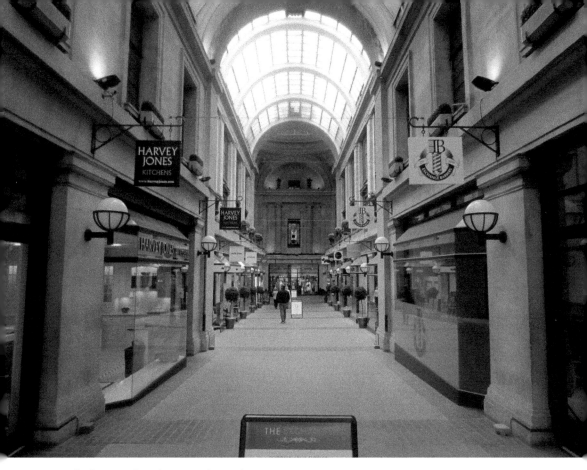

Posh shops and opulence at The Exchange.

The tobacconists aside, the shops and their wares are actually of very little interest. It is the architecture of the building that makes it worth a visit.

Art deco stonework and high-arching glass ceilings give a feeling of interwar opulence. The three spokes of the T meet in a large circular area that is directly beneath the Council House dome. The interior of the dome is also of glass, flanked by four murals depicting major events – both real and legendary – in the city's history. The murals were painted by local artist Noel Denholm Davis. He used well-known folk from the area as his models; for example, Albert Iremonger, the goalkeeper for Notts County, appears as Little John in the mural depicting Robin and his Merry Men. In the other murals, you can see the Danes capturing Nottingham, William I ordering the building of Nottingham Castle and Charles I raising his standard at the beginning of the Civil War.

This lofty, airy space was officially opened on 22 May 1929 by the Prince of Wales – the future Edward VIII. For many decades, the majority of the retail space was given over to Joseph Burton, a purveyor of posh nosh to the city's well-to-do.

After several refurbishments, and a major facelift in the 1980s, the Exchange Arcade still caters for the moneyed classes.

Looking is free though.

Film

Hollywood, Bollywood and ... er ... Nottingham?

Okay, Nottingham is not one of the great centres of the cinematic arts, although the local people do like a night out at the pictures. There are several multiplex cinemas in and around the city, although the connoisseur's choice is probably The Broadway in Hockley. With an attached, hipster-friendly, cafe-bar, they provide a variety of artsy, foreign and vintage films that probably won't make it into the bigger, more commercial establishments.

For those, like me, who do not profess to be cinephiles, the picture house of choice has got to be The Savoy. Located on Derby Road, it is the oldest cinema in the city. The art deco building was opened in 1935 and houses three screens, one of which is delightfully dinky. It has an unpretentious, old-fashioned feel that makes it a much more comfortable and welcoming place than its larger competitors.

Small it may be, but The Savoy holds its own place in cinema history, as one of the locations in the 1960 film *Saturday Night and Sunday Morning*. Widely held as one of the greatest British films of all time, this kitchen sink drama was adapted by local author Allan Sillitoe, from his own 1958 novel. It follows the (mis)adventures of 'angry young man' Arthur Seaton. By day, Seaton works, making bicycles at the Raleigh factory, but he dreams of better things – a life with meaning. This meaning is largely found through his weekend binges around the pubs of Nottingham, and his affair with a married woman. Inevitably, he puts her in the family way and drama ensues.

It's a gritty piece, typical of its time and reflective of a restless, post-war generation of working-class people dissatisfied with their position in life. Location shots, filmed around Nottingham, give the picture a real sense of place and many of those featured are still recognisable today.

The cast, headed by Albert Finney as Seaton, are wonderful, although it is notable that, for the most part, they seem totally incapable of doing a Nottingham accent. A casual viewer, unfamiliar with the setting, might be forgiven for thinking that the film was based in the grim, industrial north, rather than in the East Midlands.

More recently, Uttoxeter-born film-maker Shane Meadows has made the city his home. With cult flicks such as *This is England*, *A Room for Romeo Brass* and *Dead*

Man's Shoes under his belt, Meadows has depicted the seamier side of working-class life, in a similar way to that seen in *Saturday Night and Sunday Morning*. Again, he makes much use of local outdoor locations (perhaps, most notably, in his early feature *Small Time*), although his use of local actors who can 'do the accent' adds a great deal of authenticity.

Nottingham may not be up there with Hollywood, and the films made here lack the slick 'razzmatazz' of those made by glossy American studios. However, when it comes to realistic depictions of everyday life and people that you feel that you know, I think that the little city on the Trent has the edge.

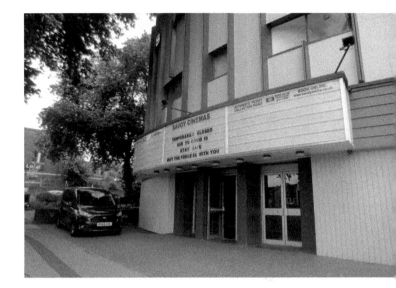

Right: The Savoy – my tip for Nottingham's best picture house.

Below: Art films and hipster food at The Broadway.

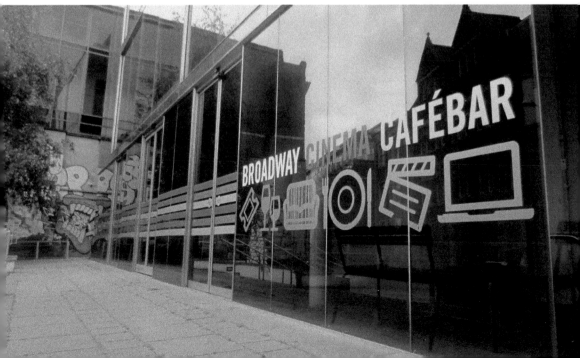

Fothergill, Watson

Once you are familiar with Watson Fothergill and his unique style of architecture, you will start to spot his buildings all over Nottingham. They are usually – although not always – built of distinctive orangey-red bricks, with little towers and flourishes which make them seem ancient, although of no particular period. There is a hint of both the Tudor and the medieval about them. Often, a date can be seen on the wall, picked out in a distinctive Gothic script.

From private homes to public houses; banks to churches and even newspaper offices, Fothergill's buildings are dotted around the city and its suburbs in such a high concentration that it is bewildering to think that they were all designed within the space of one man's career. He was responsible for over a hundred projects, many of which were on a grand scale.

Born in 1841, Fothergill was very much a man of his time. As with so many other Victorians, his work contains a nostalgic, backward-looking aesthetic, harking back to the prelapsarian days before the Industrial Revolution. Although some of his finest structures are sadly lost (*see* Albert Hall), many of them can still be seen today.

A number of shops and businesses around the city are now housed in Fothergill's buildings. In many cases the interiors have been stripped and modernised, but the occasional neo-Gothic fireplace in a bra shop, or a strangely cathedral-like setting for a gentlemen's outfitters hints at the grandeur that they would once have shown.

His Baptist Church, which was seriously damaged in a fire, still has a grand ceiling, although this is severely marred by soot. There is one clear spot that stands out against the blackness and this indicates how magnificent it must once have been. The building currently houses the Pakistan Centre, which does exceedingly good food on weekday lunch times, for a very reasonable price. Prayers are conducted within the hall and it is nice to note that, though the religion may be different, the building is still being used for much the same purpose as that for which it was built.

Fothergill's warehouse in the Lace Market.

Above: A mixture of styles on the Market Square.

Right: Stern faces at Fothergill's Express Offices.

General Ludd

The first verse of the Nottingham ballad 'Ned Ludd's Triumph' (*see* Appendix at the back of the book) makes much of the fact that Ludd's name rhymes with Robin Hood. Both are rebel heroes that are often depicted as standing up for the common man against the authorities; both are essentially outlaws; both are shadowy, semi-mythical figures.

So who was General (sometimes Captain or King) Ludd?

Well, as you almost certainly remember from school, it was from Ned Ludd that the Luddites got their name. Against the backdrop of the Napoleonic Wars, mechanisation, poor wages and widespread revolutionary sentiments, this group of skilled craftsmen came together to take direct action against the new machines that were robbing them of their livelihoods.

On 11 March 1811, a group of Framework Knitters assembled in Arnold, just outside the city boundary. That night, they destroyed sixty-three frames – all of which were of a kind that could be operated by unskilled men who had not served their apprenticeship.

Further, similar, incidents occurred over the next six years. From the initial outbreak in Nottingham, the movement spread into Yorkshire and other parts of the north of England. Tensions were rife, property was damaged, and violent reprisals on the part of factory owners cost men their lives.

The rebels hid their identities behind the *nom de plume* Ned Ludd. Threatening letters were often signed off with his name. Various legends about his true identity emerged. He may have been a Leicestershire weaver who was whipped for idleness and then, in a fit of vengeful rage, smashed up two frames. He may have been a man named Ludlam, who resented an order from his superior to 'square his needles'. His reaction to this unfathomable insult was to take a hammer and beat them into a heap.

More realistically, he was never a single individual at all – merely a personification of class resentments and fears over the impact of technological innovation.

It is sad that the word Luddite is now often used as an insult. For many in carries negative associations with being anti-progress. In reality, the Luddites were skilled men who were proud of the quality of their work and didn't want to lose the wages that supported them and their families.

I for one feel that Ned Ludd, whomsoever he may have been, deserves to take his place as a true English folk hero.

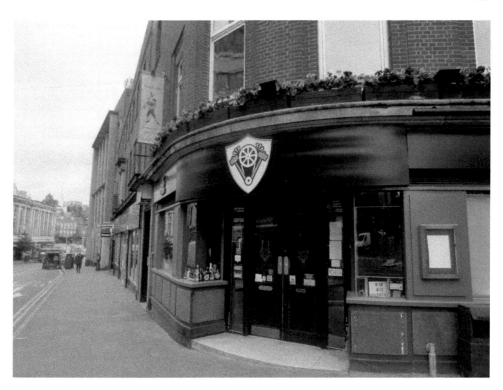

Above: The Ned Ludd – a pub with industrial history in its name.

Right: The elusive Ned Ludd.

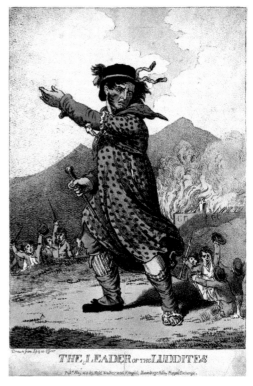

Howitt, William and Mary

'Will you walk into my parlour?' said a spider to a fly.

It's one of the most often misquoted lines in all of English literature. *The Spider and the Fly*, first published in 1828, is one of our great children's poems – a cautionary tale of seduction and flattery – and its opening line has become a shorthand for duplicity, masked by honeyed words.

The author of the poem, Mary Howitt (*née* Botham), was a Gloucestershire-born Quaker. Her husband, William Howitt, was born in Heanor, in Derbyshire. In 1823 they moved to Nottingham and it was here that they began to focus on their literary careers.

William wrote on a broad range of subjects – religion, politics, history – whilst Mary gained fame by writing children's stories. She also made a number of translations of the fairy tales of Hans Christian Anderson. Both William and Mary composed poetry.

Living in the provinces they may have been, but this did not prevent them from associating with many of the greats of nineteenth-century literature. Their connections read like a *Who's Who* of authors and poets from the period.

When Byron's corpse was brought to Nottingham, prior to burial in nearby Hucknall, the Howitts visited the casket and laid their hands upon it. William followed the funeral procession and they later befriended both Byron's widow and daughter. They also visited the Wordsworths and associated with Dickens, Gaskell and Elizabeth Barrett Browning.

Years later, Mary's most famous poem was parodied in *Alice's Adventures in Wonderland*. When the Mock Turtle and the Gryphon dance the Lobster Quadrille, they chant words that follow a familiar structure and begin with a twisted, and yet still recognisable, version of the iconic first line:

'Will you walk a little faster?', said a whiting to a snail

As Quakers, the Howitts had a strong sense of moral duty – a sense that shines through their work. It also manifested itself in their political actions.

By 1831, revolution was in the air. The House of Lords had rejected the Second Reform Bill – a bill that was set to clean up the rotten electoral system and widen the franchise. The people of Nottingham were furious. Riots erupted and property belonging to those who had down voted the bill was attacked. William and Mary watched Nottingham Castle burn from the roof of their house. They were outspoken about the fact that their sympathies were with the rioters and, when William was later elected to the council as an Alderman, his politics were officially Radical.

Public service was an impediment to his writing and so the pair soon left the city and escaped to the country. They had, however, left a lasting mark on its cultural landscape.

For people living in Nottingham now, it might be poignant to end this article on the Howitts with one of Mary's poems. It was inspired by seeing the beautiful spring crocuses that covered the green acres of the Meadows, an area that is now heavily residential and carries something of a reputation. Perhaps, if we squint a little, we might fold back the centuries, remove the terraced houses and the litter, and picture the scene through her eyes:

> *There's a joy in many and many an eye,*
> *When first goes forth the welcome cry,*
> *Of "Lo, the Crocuses!"*
>
> *The little toiling children leave,*
> *Their care, and here by thousands throng,*
> *And through the shining meadow run,*
> *And gather them, not one by one,*
> *But by grasped handfuls,*
> *There are none to say that they do wrong.*
>
> *They run, they leap, they shout for joy,*
> *They bring their infant brethren here,*
> *They fill each little pinafore,*
> *They bear their baskets brimming o'er,*
> *Within their very hearts they store,*
> *This first joy of the year.*
>
> *And here, in our own fields they grow –*
> *An English flower, but very rare,*
> *Through all the kingdom you may ride,*
> *O'er marshy flat, on mountain side,*
> *Nor ever see, outstretching wide,*
> *Such flowery meadows fair!*

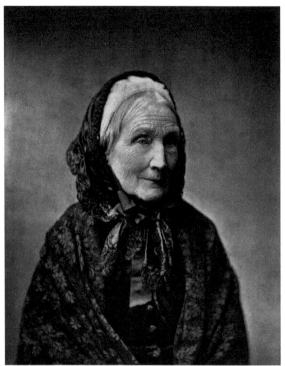

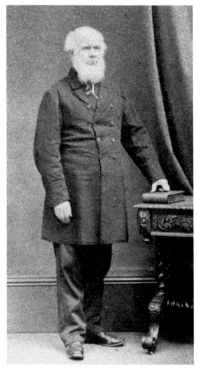

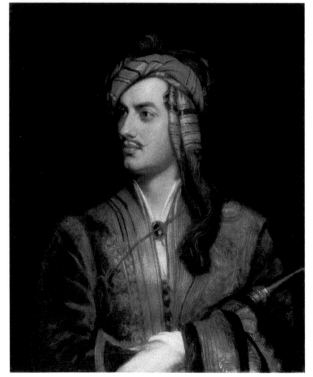

Above left: Mary Howitt.

Above right: William Howitt.

Left: The corsair himself – Lord Byron.

I

Ice

Why ice? It seems bizarre that the city should have such a connection with the stuff and yet it does seem to.

It has, in the past, been possible to skate upon the River Trent. The last time this occurred was during the 'big freeze' of 1895, when, for several weeks at the start of the year, people could take to the ice in the shadow of Trent Bridge. A splendid time was had by all, aside from the inevitable fatalities, but why should they spoil everyone else's fun?

Even now, on the Old Market Square, every Christmas a large ice rink is set up and thousands of people put on their skates for an awkward and unsteady slide about.

In 1939, the Nottingham Ice Stadium was opened. It seems incongruous, given the period, but there were attempts to create a professional ice hockey team for the city. The war got in the way and for the duration, the stadium was used as a munitions store.

In 1946, however, the Nottingham Panthers were formed and since then they have gone on to perform as one of the most popular and successful teams in the country.

But the Panthers were not the only people to come out of the Ice Stadium and take the world by storm. This was the practice rink for two of the greatest – if not the greatest – figure skaters of all time: Jane Torvill and Christopher Dean, both of whom hailed from the city.

In 1984, they took the gold medal at the Sarajevo Winter Olympics. Their iconic routine – performed to Ravel's *Bolero* – garnered them the highest score in the history of the sport. It also attracted record-breaking television audiences, with 24 million people in the UK tuning in to watch their victory.

Sadly, after six decades of service, the Nottingham Ice Stadium began to show its age. It was demolished and replaced by the National Ice Centre – a large arena that still acts as home to the Nottingham Panthers. Suites within the building are named in honour of Torvill and Dean and a large paved area outside of the main entrance glories in the name 'Bolero Square'.

As well as providing facilities for ice hockey, figure skating and speed skating, the centre is also attached to the Nottingham Arena. Here you may see some of the

greatest names in showbiz – from the poetic croakings of Bob Dylan to prize fights from Carl Froch.

In answer to my own question, I have no idea why the people of Nottingham have such an affinity with ice, but they undeniably do.

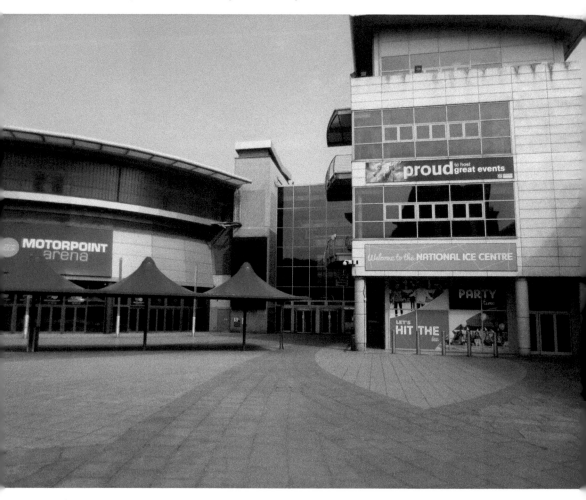

Bolero Square.

J

Jewish Burial Ground

Oldknow is a very rare surname, although at one time it was an important one in Nottingham. It was my grandmother's maiden name, and so I always take notice if I see it on a street sign, on a list of subscribers for a volume of Victorian poetry, or in an old record of court proceedings (that particular Oldknow was the judge and not – thankfully – the defendant).

I was therefore very excited indeed to discover that, on 26 February 1823, the first stone in the construction of a new Jewish burial ground was laid by the Mayor of the Nottingham. This was a mayor who held the incredibly heroic moniker of Octavious T. Oldknow. The ceremony was also attended by Rabbi Moses Levi and other members of the Jewish community. The rabbi was dressed in his robes and he chanted the 91st Psalm as he processed three times around the perimeter. Prayers were then said for the royal family and for local dignitaries, and then the 133rd Psalm was given:-

Behold, how good and how pleasant it is for brethren to dwell together in unity!

The tiny plot, an area of waste ground measuring 144 square yards, was procured on a 999-year lease, priced at a penny per annum. It is located at the top of South Sherwood Street, just a stone's throw away from the impressive Rock Cemetery, which it pre-dates by a good quarter of a century. It is a humble, walled affair, invisible to anyone unaware of its presence and dwarfed by its near neighbour. Only a small carved sign over the gate, faded into near illegibility and partially obscured by ivy, gives any indication as to what might by found behind the high wall.

THIS BURIAL GROUND WAS GIVEN TO THE COMMUNITY BY THE CORPORATION OF NOTTINGHAM 5586 / THE GROUND WAS CLOSED 5629 'THE DUST RETURNETH TO THE EARTH AS IT WAS BUT THE SPIRIT RETURNS TO GOD WHO GAVE IT.'

The dates are, of course, given in the Hebrew calendar. Given how secluded it is, the choice of the 91st Psalm seems appropriate:

> He that dwelleth in the secret place of the most High shall abide under the shadow of the Almighty.

Whilst there had been a Jewish community in the city during the Middle Ages, Edward I's Edict of Expulsion (1290) forced them – along with all of England's Jews – into exile. Nottingham's community did not re-establish itself until the turn of the nineteenth century.

By the 1860s the tiny plot was full and a bigger space was needed. A second, larger cemetery was built elsewhere. Fifteen headstones still remain in this abandoned spot, with faded inscriptions in both Hebrew and Latin. On some of them, these inscriptions are accompanied by English translations.

Although largely forgotten and unknown, this tiny plot is protected as a place of special historic interest. It is not open to the public, and remains a tiny monument to one of the city's peripheral communities two centuries ago.

A door that is easy to miss.

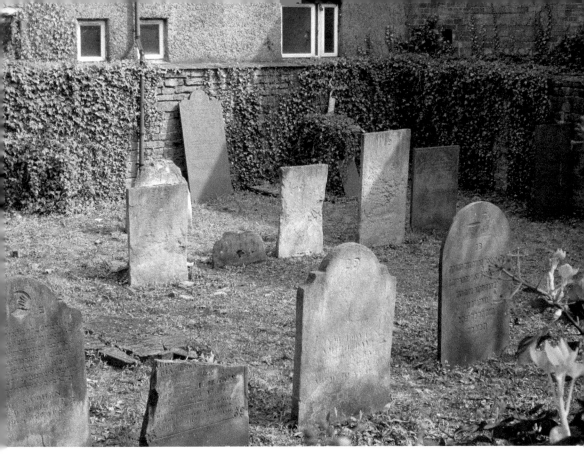

Above: Jewish graves in the little cemetery.

Right: Inscriptions in Hebrew.

Kilpin, Herbert

Nottingham has several claims to fame in the world of Association Football. It is the home to two major football clubs, Nottingham Forest and Notts County, the latter of which is the oldest professional club in the world.

For many fans of the game, the city will always be associated with the name of Brian Clough. The outspoken northerner was instrumental in gaining a slew of successes for Forest in the 1970s and 1980s. There is a statue of him just off the old market square and a road connecting the city with her neighbour/rival, Derby, is named in his honour.

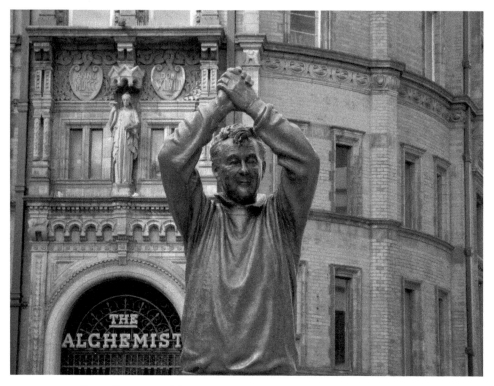

Nottingham's footballing hero of the 1980s – Brian Clough.

It is perhaps surprising then, that the city was home to a figure that was even more vital to the history of the Beautiful Game.

Halfway up Mansfield Road, on the way out of town, you may notice a building with the A. C. Milan emblem in the windows. There is a green plaque on the wall in honour of Herbert Kilpin.

Born in 1870, Kilpin grew up in the aforementioned building. As many young Nottingham folk did, he went into the lace trade, while in his spare time he played football for a couple of local teams.

The textiles industry soon took Kilpin abroad. In 1891, he moved to Turin. His new boss, one Edoardo Bosio, shared Kilpin's love of football. He founded Italy's first ever football club – Internazionale F.C. Torino. Kilpin joined the team and became the first Englishman ever to play in Italy.

In 1899, Kilpin was living in Milan. Here, he and a number of other English ex-pats founded the Milan Foot-Ball and Cricket Club – later to be renamed A. C. Milan. The cricket may have gone from the club's name but they do still keep the English spelling of Milan in honour of their roots.

Since Kilpin's time, the club has remained consistently in the top flight of Italian football, proving itself to be one of the most successful teams in the world.

Not bad for a lad from Mansfield Road.

Nottingham's modern football Mecca.

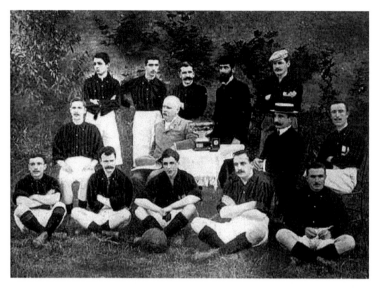

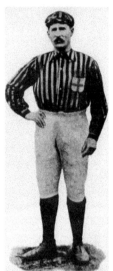

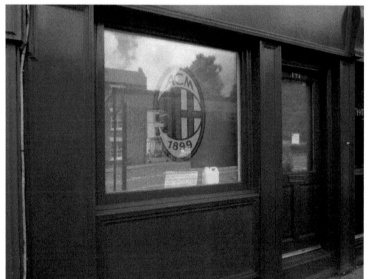

Above left: Kilpin (back row, centre), posing with his teammates.

Above right: Herbert Kilpin.

Left: The birth of a legend.

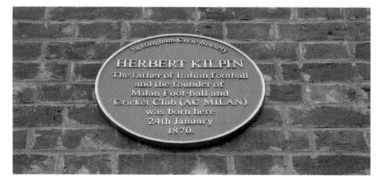

Kilpin's green plaque.

L

Lace

There are several industries that typify Nottingham. The beer has long been famous (or should I say infamous) and Raleigh Bicycles, Boots the Chemist and Player's Cigarettes were all, at one time, major employers, but only one trade is synonymous with the city – lace.

A wander around the Lace Market, with its grand, impressive former warehouses, is enough to show how lucrative the lace industry once was, and what a key role it played in the city's economy. This is still the most architecturally splendid part of town.

I was once lucky enough to do a room usage survey on the Adams Building – a former lace showroom and warehouse, which is now part of Nottingham College. This is the largest building in the Lace Market. During the survey, I was given the opportunity to become familiar with this vast rambling edifice. It was originally opened in 1855, and displays a beauty that is very much of its time. No one ever blended beauty and functionality quite as well as the Victorians. From the pretty lacework-style carvings around the main door, to the airy loft spaces, this is a delightful building that, in its current usage, can only remind one of Hogwarts.

The Adams Building and its neighbours owe their existence to a man named William Lee. Lee was born in nearby Calverton in 1563. Doubtless an amorous youth, he was frustrated to find that a girl that he was courting took much more interest in knitting than she did in his advances. Not to be defeated, in 1589 he invented the stocking frame knitting machine – a device that would revolutionise the way that fabric was made and free up his lady for more romantic activities.

How much attention he received from the lady is not recorded, but we do know that the machine was repeatedly refused patents by Elizabeth I. Presciently, given that Nottingham would later become the well spring of Luddism (see *General Ludd*), this was probably due to fears that it would put skilled craftsmen out of work.

However, after making a few improvements, he was able to set up a working industrial centre, creating knitted goods, in Nottingham. Over the coming centuries, the East Midlands became the recognised heartland of the knitting trade, throughout the Empire.

Further adjustments to the frames allowed them to make lace and, with the coming of Arkwright and the Industrial Revolution, a city-defining trade became fully fledged.

That is now largely over – some Nottingham lace is still made, although this is on a much smaller scale. Nevertheless, memories of the industry can still be seen around the area. The old warehouses, of course, remain but they are now put to quite different uses. Elsewhere, newer ventures often tip their hats to the past. A recently opened public house, just around the corner from Weekday Cross, is named The Lacemaker's Arms. It is heavily themed, with archive footage of lace factory workers projected on the walls, and bits of ephemera displayed in glass cases. Across the road, the hideous eyesore that is the Nottingham Contemporary art gallery does subtly show its roots by having small lacework patterns on its exterior.

There are movements afoot to make St George's Day a public holiday in England. Might I suggest that St Catherine's Day, which marks the patron saint of lace makers, would also be a fitting celebration for the people of Nottingham to observe.

The beautifully ornate door of the Adams Building.

Pillar box and phone box – an England of yesteryear among the lace warehouses.

Above left: My favourite sign in the whole city, situated in the Lace Market.

Above right: A green plaque for the man behind the lace.

Above: Lacey stonework on the Adams Building.

Below: Easy-to-miss lace motifs of the Nottingham Contemporary art gallery.

Lions

'I'll meet you at the lions.'

With these simple words has begun many a romance and many a drunken night out. The two large, concrete statues of lions that flank the front of the Council House have become both a landmark and an obvious meeting place in the city. We have all, at some point, stood by them, scanning the passing crowd for a familiar face. We have all, as children, clambered up onto their backs. Even the city's free arts and culture magazine is named after one of them – it states its political leanings alongside its location with a name like Left Lion.

Designed by the local sculptor Joseph Else (who was responsible for much of the rest of the statuary on the Council House), the two art deco lions are, rather magnificently, called Agamemnon and Menelaus. In more recent years, they have been renamed – by the less classically minded – as Leo and Oscar.

Their ineffable, effable, effanineffable names are known only to themselves.

The names of the Greek heroes seem the most appropriate of their titles. They are majestic and slightly angry-looking big cats that do not look as though they suffer fools gladly.

Interestingly, a miniature version of these lions can be found sitting on the roof of the White Lion pub in nearby Beeston. This presumably weighs less than the 2 tons carried by its urban relatives.

For a more friendly feline, I'd advise a trip to St Mary's Church in the Lace Market. Not only is the church a fabulous sight in and of itself, but the statue of a golden lion that stands guard at the main door (see *Unicorn*) is a delight and much more welcoming than the sour pusses on the square.

 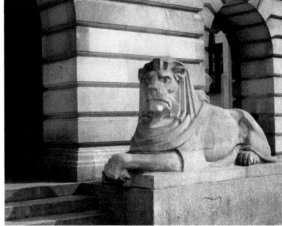

Above left: Agamemnon or Leo – call him what you will ...

Above right: ... and his partner Menelaus or Oscar.

The Long Walk

Slavomir Rawicz was either one of the greatest adventurers or one of the greatest liars of the twentieth century. He is best known as the author of *The Long Walk*, which was published in 1956. The book, which was actually ghost-written following a long series of interviews with Rawicz, tells an extraordinary tale of escape and adventure.

Rawicz was born in 1915 in Warsaw, Poland. In his early twenties, he joined the army and had attained the rank of lieutenant by the time Nazi Germany and Soviet Russia carved up his country in the autumn of 1939. We know that he was then apprehended by the Russian authorities. The book describes a rigged trial, on a charge of espionage, which followed his arrest. He was sentenced to twenty-five years of hard labour in a Siberian prison camp.

A gruelling three-month journey to the gulag and dehumanising conditions when he arrived only served to strengthen Rawicz's determination to escape. In 1941, he and six other prisoners made a desperate bid for freedom. They succeeded liberating themselves from the camp only to find themselves in hostile enemy territory, in one of the most inhospitable places on earth.

Undeterred, they then undertook an incredibly audacious journey south from the bleak southern Arctic wastelands of Siberia, across the searing, waterless heats of the Gobi Desert, over the Himalayas into Tibet and then, finally, into the welcoming arms of British authorities in India.

Along the way they met with a seventeen-year-old Polish girl. The escaped prisoners took her with them on the, seemingly impossible, journey. She and several of the men did not survive.

The Long Walk is a tremendous adventure story – it's a rip-roaring page turner that deservedly became a bestseller. The fact that it almost certainly isn't true only partially detracts from the entertainment value.

In the early twenty-first century, various documents came to light which cast Rawicz's story into doubt. It is true that he had served as a lieutenant and that he was put on trial by the Russians. He may not have been charged with spying though. It is more likely that he killed a Russian officer during the invasion. He was taken to a gulag, but Soviet documents indicate that he was released in 1942 as a part of a general amnesty.

So *The Long Walk* is a work of fiction? Well, possibly, although another former Polish soldier, Witold Glinski, has come forward to claim that the events did take place, but that they happened to him! His claims have also been disputed.

And what has all of this got to do with the city of Nottingham?

Following the war, Rawicz settled in Sandiacre, not far from the city. He got a job as a technician at the Trent Polytechnic, now Nottingham Trent University – an institution that your humble author occasionally also works for.

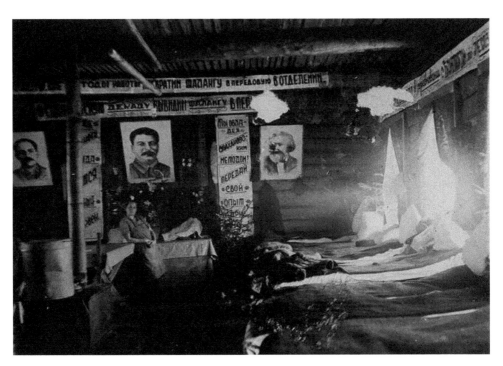

Living conditions in a Russian gulag.

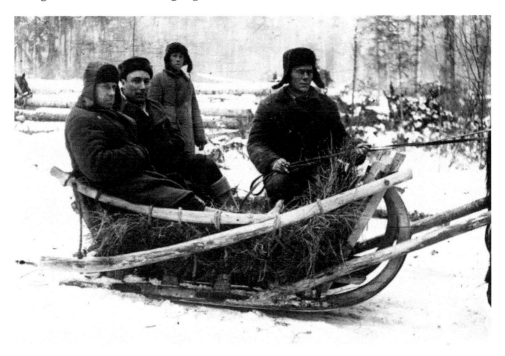

Gulag workers in Siberia – conditions Rawicz claims to have escaped from.

Mothering Sunday

Ah, Mothering Sunday! The day when we all go out to gather posies of primroses from the hedgerows and put on our chef's hats to bake simnel cakes as simple, homespun, presents for dear mama!

And yet it hasn't always been thus.

Call it what you will – Mid-Lent Sunday, Laetare Sunday, Refreshment Sunday, Rose Sunday – the fourth Sunday in Lent has, for centuries, been associated with motherhood. In the dim and distant past, prior to the Reformation, the maternal role was filled by a far more ecclesiastical matriarch – Mother Church.

Traditionally, parishioners would, on this day, return to the church in which they were baptised, or the cathedral of the local diocese. Of course, young folks who were working away in service were permitted a holiday in which they were expected to return home. For many, this was one of the few occasions in the year when the whole family would be under one roof. It is little wonder, in this familial atmosphere, that the celebration of mother church and the real joy of seeing actual mothers became intertwined.

By the seventeenth century, this had become the day on which you made an extra special fuss of your mum. The long-held tradition of gathering flowers or making a gift of simnel cake on this day may be traced at least as far back as this period.

This was not, however, to last. As with so many quaint and pleasant customs, Mothering Sunday was unable to bear the strain brought upon it by the great industrial forces of the nineteenth century. Mass movement, mass entertainment and mass urbanisation all took their toll, and by the beginning of the last century, the practice was all but forgotten.

This is where we introduce the heroine of the hour – Nottingham resident Constance Penswick-Smith.

Inspired by the adoption of a similar, yet unconnected, celebration in the United States, she created the Mothering Sunday Movement. 1914 was obviously a slow year for world affairs as it was in that year that the movement began its crusade to spread 'a knowledge of the beautiful old custom and its significance'. The daughter of a vicar, Constance was keen to highlight that the festival was a religious one, celebrating both our earthly and universal mothers.

SIMNEL CAKES.

Simnel cakes – the traditional gift for Mothering Sunday.

Campaigning continued throughout the war years and by 1920, she had published her opus – a concise pamphlet entitled *The Revival of Mothering Sunday*.

Florists, chocolatiers and purveyors of chintzy tat throughout the land sensed the commercial possibilities. By the 1950s, Mothering Sunday had been shrink-wrapped and marketed for the post-war consumer and, from then on, we have all been made to feel guilty for not spending money on our dear old mothers on what is, it goes without saying, the best opportunity to turn a profit between Valentine's Day and Easter Sunday.

I'm not sure that the modern Mothering Sunday – or Mother's Day as our cousin's across the Atlantic have convinced us to rebrand it – is everything that Constance had hoped for. Perhaps fortunately, she died in Nottingham in 1938, and never got to see the worst excesses of the season.

Ironically, the creator and champion of the modern Mothering Sunday left no children to remember her in the middle of Lent.

Mushy Peas

Nottingham's annual Goose Fair is one of the largest funfairs in the country. The orgiastic blend of noises, smells and lights feel like receiving a snooker ball-filled sock to the senses. Nowhere is this more true than in amongst the long lane of food stalls that runs along the back of the fair. Candyfloss, burgers, toffee apples, and brandy snaps all vie for the attention of hungry patrons. As well as these fairground favourites, cuisine from across the globe can also be found – wafting delicious exotic smells into the already heady mix of ozone and generator fumes.

'Typical of a modern fair,' I hear you cry.

But look at most of the stalls and you will see a difference. On many of them you will see signs offering Nottingham's favourite dish of choice – mushy peas and mint

sauce. 'The Only Fresh Peas on the Fair' several of the stalls proclaim. Large heated trays hold gallons of green slop and metal bowls on the counter allow patrons to ladle sauce onto their disposable cupfuls. Personally, I always try to get mine from the stall behind the brick Scout Hut at the edge of the site. The money goes to the local troupe.

Mushy peas may seem an odd choice for a local delicacy, but the good people of Nottingham love them. You have not really experienced life in the city until you have been in a pub and heard the call of 'Hot peas!' from the landlady, who has just unveiled a steaming tray of the verdant pulses. See how the locals dash to fill up their bowls!

There is even a stall in the Victoria Centre market devoted to selling them (see *50 Gems of Nottinghamshire*). Here, you can eat them in seated comfort whilst sharing a large communal bowl of mint sauce and chatting about the vagaries of city life.

It's hard to say how, or when, the city became so devoted to the dish. The phrase 'mushy peas' is of surprisingly recent coinage – the OED traces it to a 1973 episode of *Last of the Summer Wine*, in which the character Norman Clegg is heard to utter the line: 'We only left him last night. Stuffing his face with fish, chips and mushy peas.' Of course the act of cooking peas until they go mushy dates back much earlier and there is evidence that there was a regular mushy pea stall in one of Nottingham's markets at least as long ago as the 1960s.

Whatever the origins of this civic fascination, it doesn't show any signs of dying out.

Nottingham's national dish.

N

Nottamun Town

In the early years of the twentieth century there was a mass scramble to save England's traditional culture from what was seen as the degrading influence of modern entertainment. If our national music, song and dance was to be preserved against the evils of the Music Hall, gramophone records and the cinema, some serious effort would be required. Folksong collectors, such as Ralph Vaughan-Willaims, Lucy Broadwood and Percy Grainger, took to the leafy lanes and neglected byways of rural England, on a mission to note down any scraps of old song that could be dragged from the minds of ancient farm labourers and toothless spinsters.

This was the First English Folksong Revival and its leading light was a man by the name of Cecil Sharp. His passion for collecting was unbounded – and where did he go to find his songs? Where could he possibly locate unspoilt renditions of quintessentially English music, untainted by show business?

The Appalachian Mountain region of the United States of course.

In 1917, he collected a song in Kentucky that has gone on to be recorded by some of the greatest names in popular music.

Nottamun Town, or *Nottingham Fair*, is a strange song filled with surreal, self-contradictory imagery. It is sung to a haunting, ethereal tune (famously used by Bob Dylan for his song *Masters of War*). The lyrics tell of a journey through a topsy-turvy, *Alice in Wonderland* landscape, as can be seen in the version included in the appendix at the back of this book.

In some versions, the words are enough to make a man of the world blush.

Many people have connected the song with the city of Nottingham. Nottamun, many have theorised over the years, is surly a corruption resulting from a long process of musical Chinese whispers. (It is perhaps interesting to note that in the Eastern part of the county, where I grew up, we still refer to the city as Nottnum). Many have theorised that this is an English song taken over to America and then forgotten at home.

So what is it all about? Well, the two main theories that crop up, almost everywhere that the song is mentioned, are:

1) That it is related to the traditional mummers plays that were once common at Christmas. The plays, insomuch as they have a plot, tell a tale of backwards logic and

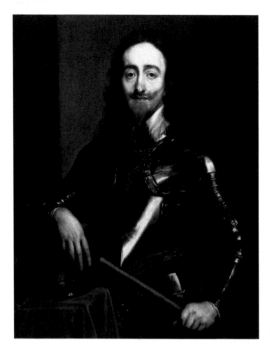

Charles I – the reason the world was
turned upside down in Nottamun Town?

nonsense dialogue. Certainly the folk-singer Jean Ritchie, a relative of the women from
whom Sharp collected the song, believed that the song was a ritual piece associated
with the Nottingham mummers.

2) That it is a reference to the English Civil War. It was near Nottingham that Charles
I raised his first army and imagery of a world turned upside down – a world where
the populace had turned upon their king and subverted the natural order of things –
was common at that time.

More recent research has linked the song *Teague's Ramble to Camp* – a sort of
eighteenth-century Paddy and Murphy joke in song form – which tells the tale of an
Irishman coming to England and having a series of self-contradictory adventures.
If this is the true origin of the song, then it may have nothing to do with dear old
Nottingham at all!

Whichever theory you prefer, this is a beautiful and haunting song – once heard,
never forgotten.

Nottingham Catchfly

Look around the Castle Rock – the sandstone outcrop upon which Nottingham Castle
is built – and you will fail to see the white, hairy-leafed windflower which shares its
name with the city.

The Nottingham Catchfly (*silene nutans*) is the county flower of Nottinghamshire.
It is abundant all over Europe, in parts of Asia and even, as an introduced species, in

North America. It is a sultry temptress that fills the night air with a heavy perfume, so as to attract moths.

At one time, it grew upon the walls of the castle, hence its name, but some nineteenth-century building work displaced it and it has failed to return. In fact, whilst relatively common in other parts of the UK, it is totally unknown within the county.

Maybe one day it will come home again.

Above left: Castle walls – can anyone see any catchfly?

Above right: Walls devoid of flowers.

Right: Nottingham catchfly used, alongside brambles, as a decoration in this Italian text. (Image courtesy of the Getty Museum)

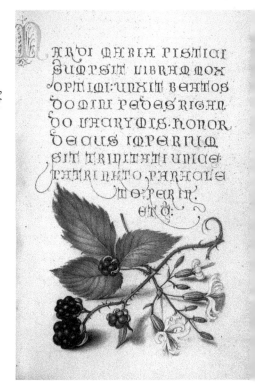

Nottingham Pudding

Mary Eaton's domestic guide *The Cook and Housekeepers Dictionary* is a curious work. It was published in 1822 and contains all of the information that a conscientious housewife or domestic servant need ever know.

Following sections on dealing with nosebleeds and the receiving of a notice to quit, is a recipe for Nottingham Pudding.

Personally, I'd never heard of it, but I thought I'd give it a try ...

Mary Eaton gives the recipe thus:

> Peel six large apples, take out the core with the point of a small knife or an apple scoop, but the fruit must be left whole. Fill up the centre with sugar, place the fruit in a pie dish, and pour over a nice light batter, prepared as for batter pudding, and bake it an hour in a moderate oven.

That all sounded simple enough, so I set to work. I only had 'eaters' available, so I used those rather than cooking apples. For a true Nottinghamshire flavour, you should perhaps use Bramleys as these were first cultivated in the nearby minster town of Southwell. As this was going to be part of my family's Sunday dinner, I used the leftover Yorkshire pudding mix for the batter. I stuffed the apples with demerara sugar and I also added a sprinkling of cinnamon to flavour.

And the result ...

... Was very pleasant. The apples were still a little firm for my liking, so in future I will use 'cookers'. The sugar had sweetened the batter, preventing it from

Peeled and cored – my preparations for Nottingham Pudding.

becoming the fruity toad-in-the-hole that I was expecting. In short, it was the kind of English school dinner stodge that would sit comfortably alongside jam roly poly or spotted dick.

This is definitely a neglected gem and, doused liberally with custard, it should be reappearing on our dinner table regularly in future.

Above: The finished product.

Right: And serve with a dollop of custard!

Old General

The year 2016 was a troubling time for the people of Hyson Green. One of their most beloved landmarks was under threat. The Old General public house was due to be redeveloped – in layman's terms, this meant the demolition of the building and the loss of another watering hole in what is now a rather parched area of the city. More alarmingly, it meant the removal of the little coloured statue which had stood, in a protective glass case, over the door for more than a century. It was a rather novel sort of pub sign and was held dear by the local populace.

For one thing, how would they know when it was Christmas?

Every December, since the turn of the twentieth century, the statue had been dressed as Father Christmas – much to the delight of local girls and boys.

This was appropriate enough, as the real-life 'Old General' upon the whom the statue is modelled was not a military man in the conventional sense, but the leader of an army of children.

Benjamin Mayo cut an odd figure to say the least. Born in or around 1789, he would – in the parlance of the time – have been deemed a half-wit. As we can see from the statue and from descriptions of the man, he was also somewhat deformed. His bent posture made him appear much shorter than he actually was and a malformed leg caused him to walk with a distinctive jog-trot. However, where body and intellect were lacking, an engaging personality shone through.

He had been a resident at the St Peter Poor House. So charming was he that, when the institution was dissolved, the former master – one Mr Hudson – took Mayo into his own home to spare him from the strictures of the Union Workhouse. He lived there for a number of years, until Mr Hudson moved away.

It was not only Mr Hudson who took a shine to him. The whole city knew and recognised him – so much so, that Mayo reckoned himself second only to the mayor. His most apparent civic duties took place around Mickleton Monday.

Have you ever wondered when Mickleton Monday is? I have, and so did the people of early nineteenth-century Nottingham. Apparently if you were to ask the General, he would reply 'I don't know yet, the mayor hasn't axed what day will suit me.' Eventually, and presumably with Mayo's permission, the great day would come.

The Mickleton Jury – evidently a rather serious body, armed with official notebooks – would beat the bounds of the city and then survey the streets for any unlawful obstacles. Mayo was on hand to remove any such offences, at the head of an army of boys. Prior to this important duty, the force would liberate any unfortunate comrades that were not allowed to join them, by laying siege to the schools with mud bombs. A particularly obstinate schoolmaster may bribe the General to go away, with a tuppence backhander, which I am sorry to say that he was open to accepting.

Having removed any offending obstructions – with a fine display of anarchic gaiety – the army would then march on Nottingham Castle. Here, they would demand sweetmeats and gingerbread. These were duly thrown to them from the castle gates.

Other stories relate Mayo's extraordinary wit. He was accustomed to make money as a 'flying stationer' – a purveyor of newspapers and 'horrid murder' sheets. Famously, he once sold copies of 'the grand and noble speech as the Duke of York made yesterday'. When disgruntled customers discovered that the sheets were blank, Mayo assured them that 'the Duke said nowt'.

Mayo never wore a hat, whatever the weather, until he reached the age of sixty, when he began to don a general's one, worthy of his rank. Also, in his later years, he dispensed with the grey clothes of a pauper that he usually wore and put on the famous red coat that generations of people from Hyson Green associate with his statue.

When Mayo died, in the Union Workhouse, a memorial was purchased in his honour. It read:

BENJAMIN MAYO COMMONLY KNOWN BY THE NAME OF 'THE OLD GENERAL' DIED IN THE NOTTINGHAM UNION WORK-HOUSE 12TH JANUARY 1843, AGED 64 YEARS. A FEW INHABITANTS OF THIS TOWN, ASSOCIATING HIS

The Old General. (Image courtesy of the Nottingham Hidden Histories team)

PECULIARITIES AND ECCENTRICITIES, WITH REMINISCENCES OF THEIR
EARLY BOYHOOD, HAVE ERECTED THIS TABLET TO HIS MEMORY.

Later, the famous statue was carved by a local mason – one Joseph Holmes. It was
initially displayed in the very castle that Mayo had once besieged. When Holmes'
brother built the Old General public house, the statue moved in and the rest is history.

And as for the worried people of Hyson Green? Their initial fears have been
allayed. The statue's case may be gone, but developers have assured locals that the
General is safe and well, and ready to reclaim a position in the newly built retail and
residential units.

Old Market Square

In 1951, to coincide with the Festival of Britain, a short documentary was made by
members of the Nottingham and District Film Society. The film celebrates what are,
probably, the city of Nottingham's most iconic features – the Old Market Square and
Council House that stand, both physically and metaphorically, at its heart.

This is the largest non-metropolitan market square in the whole of the UK. It has
been there for eight centuries, marking what was once the meeting point between
Norman and Saxon settlements. The grainy, black-and-white footage shows it to be
a busy hub – a huge space that acts as a bus terminus for thousands of commuters.
Shoppers swarm around the pillared edges of the piazza; people wait for friends and
loved ones beside the famous lion sculptures. Idlers lounge, demagogues rant and,
once the sun has gone down, revellers spill out into the cool night air.

The clothes are old fashioned and the faces of the men and women, captured for
posterity almost seventy years ago, are those of a bygone age. These are the faces of
people well acquainted with rationing and still haunted by the recent memory of war.
And yet how familiar they are. Go to that very square today and you will see a scene
only superficially changed from the one captured in 1951.

That is not to say that you will not see any differences. A major facelift for the square
was conducted in the early years of the twenty-first century. After seemingly eternal
building works, carried out behind high fences, the results were finally revealed in the
spring of 2007. The people of Nottingham were, frankly, underwhelmed by the sight
of a large, flat, empty space. The fountains that had previously been a major attraction
to the square were gone, replaced by an asymmetrical water feature at one end and a
lot of grey nothingness in the middle.

The 'improvements' my not be aesthetically pleasing, but the huge, empty area has
proved remarkably useful for hosting a rolling roster of seasonal events. In February
there is a giant Big-Wheel, known as the Nottingham Eye; in summer a fake beach
is constructed, complete with deckchairs, water and a variety of seaside shacks – all
very appealing in landlocked Nottinghamshire; in December there is the obligatory

German Christmas market, complete with skating rink, merry-go-rounds, helter-skelter and false snow; and, in between, there are a host of other events, concerts, markets and shows.

This square has been at the heart of the community for the best part of a millennium, and it shows no signs of losing its important role.

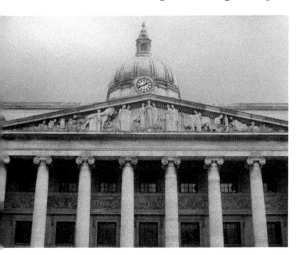

Above left: The glorious frieze on the front of the Council House.

Above right: A contemporary water feature on the Old Market Square.

Below: The largest non-metropolitan square in England.

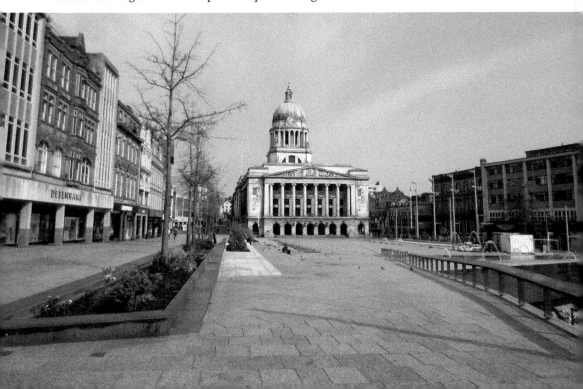

Paper Lace

The 2010s were, in many ways, the breakthrough period for Nottingham's music scene. Early in the decade, punters at many local live music venues were treated to performances by a moody young teenager who looked like an extra from Quadrophenia and sounded like the Everly Brothers. Jake Bugg took the album charts by storm. Later, this success would be mirrored by another of the city's acts – Sleaford Mods.

The people of Nottingham were basking in this new-found musical glory. Finally they were on the map. Stand aside Liverpool, there was a new kid on the block.

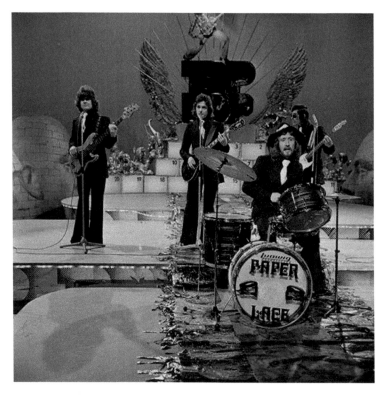

Paper Lace hitting the big time on Dutch telly! (Image courtesy of the Beeld en Geluid – an initiative of the Netherlands Institute for Sound and Vision)

And yet musical fame wasn't something entirely new to the city. Back in the days when The Beatles were still riding high in the hit parade, a little pop group was cutting its teeth in musical venues around the East Midlands and beyond.

Formed in 1967, Paper Lace started out playing covers of contemporary pop hits. They toured extensively for years, honing their craft on the seedy club circuit, but it was not until 1973 that success on the TV talent show *Opportunity Knocks* propelled them into the limelight.

Their first hit – *Billy Don't Be a Hero* – tells of the death of the eponymous soldier in an unspecified war. The warning that forms both the chorus and the title is issued by a lover who is left behind as Billy goes off to fight. She begs him to keep his head down and return to make her his wife. Paper Lace delivered the tragic tale in a chirpy, saccharine style, complete with whistling, that almost tips over into parody.

It remained at number one for three weeks in the March of 1974.

Later that year, their follow-up single, *The Night Chicago Died*, went gold. It peaked at number three. Then came their final big hit, *The Black Eyed Boys*, which got to number eleven.

The band's major chart successes ended in 1974, but that wasn't the end of Paper Lace. At the time of writing, two versions of the band currently perform at venues across the UK.

Lets see if Sleaford Mods have that level of longevity!

Player's Navy Cut

Nothing conjures up images of the sea in quite the same way that Nottingham does. It may be 50 odd miles from the coast, but that doesn't prevent it from having a long-standing association with one of the most famous nautical figures in the world.

The packaging for Player's Navy Cut cigarettes, which depicts the head of a sailor set against a background of the sea, complete with ships, and framed by a life-ring, represents one of the most instantly recognisable commercial images ever created. The brand was launched in 1883 and was, for decades, one of the most popular on the market – both at home and abroad. Much of this popularity can be attributed to the handsome, square-jawed man on the tin. The word 'Hero' was emblazoned on the front of his cap – an appeal to customers to identify with the stiff upper-lipped, courageous Briton that they could be ... If only they smoked the right fags.

So recognisable was the image that the prog rock band Procol Harum used a parody of it on the cover of their 1969 album *A Salty Dog*. Back in the days when the brand was a familiar fixture in smokers' pockets, few would have missed the joke.

Interestingly, the trademark image of Nottingham Castle, which was included on the packaging as a seal of quality, was, during the 1930s, the most viewed image of a castle anywhere in the world.

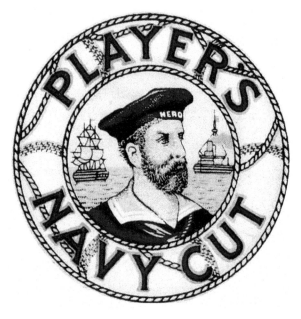

A handsome sailor and an iconic brand.

The company behind the iconic tin, John Player and Sons, was founded in Nottingham in 1877. It quickly grew into a major manufacturer and by the 1950s was employing 11,000 people.

It's difficult to feel too saddened by the demise of a tobacco firm, but Player's does mirror the sorry decline in other areas of Nottingham's manufacturing sector. As with the other major employers in the city, it fell into foreign hands and, in the early twenty-first century, the last of the company's factories closed. In 2016, after almost 140 years, Nottingham ceased to manufacture cigarettes.

Plough Bullocking

There are many quaint and delightful customs that are still practised across our nation. In the twenty-first century, with our supportive welfare state and our modern amenities, many of them have lost the bitter sting that they would have possessed in former years. Many traditions that take place in winter still have echoes of a hungry past – exhortations for the money or food that were in short supply during the cold, workless months. Just think of carol singers and their musical demands for 'figgy pudding' to be brought out.

One such custom, observed in Nottingham and the surrounding area in former times was 'Plough Bullocking'. This was done, in the early decades of the nineteenth century, on Plough Monday, which is the first Monday after Epiphany. Its connection with ploughing speaks of an agricultural origin, but for urban practitioners, it was merely an excuse for devilment and demanding money with menaces.

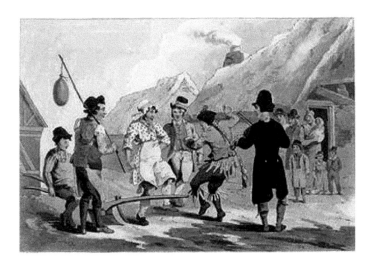

Merry plough-boys out 'bullocking' on Plough Monday.

Dressed in clothes that were decorated with ribbons, and carrying wooden swords, they would maraud around the district with their faces crudely daubed with lamp blacking, or paint. Accompanied by a witch (represented by a man in drag) and using a whip with an inflated bladder on the end to drive a team of men pretending to be horses, they would visit householders. There they would sing and make 'rough music' and would demand money for their performance. A failure to pay up would lead to reprisals – gardens and front steps would be dug up.

Money gained by these vandals would, of course, be used to fund drunken escapades over the coming week and respectable folks were well advised to keep away during these bacchanals, lest they be accosted by the intoxicated bullocks.

Inevitably, this kind of behaviour could not go on unchecked. Bullocks were kept on their toes by the local police and an order to pay for damages was not unheard of. From the 1820s onwards the authorities began to crack down on the practice. Nevertheless, Bullocks were still to be seen in and around Nottingham well into the twentieth century.

Pollard, Su

It may be that my grandmother did not lead the most exciting of lives, but she did always tell the tale of her one great brush with celebrity. Once, whilst working on the check-outs at the Co-op, she had served Su Pollard's mum with a tin of crab meat.

Few people have ever embodied the spirit of a place so accurately as Su Pollard does Nottingham. You want to know what the city is like? Watch an episode of the BBC sitcom *Hi-de-Hi!* Su's character, Peggy Ollerenshaw, is everything that Nottingham stands for rolled up into one adorable, hilarious package. With a broad accent, a friendly and simplistic optimism, and a kind of clumsy, anarchic pluck, Peggy captured the hearts of the nation.

P

63

She played almost identical roles in other similarly nostalgic Croft and Perry-penned romps – *You Rang M'Lord?* and *Oh, Doctor Beeching*.

The East Midlands are often ignored in the media and it is such a joy to see someone who is archetypally Nottingham on screen, speaking in an accent that is so familiar to local people but so alien to outsiders (people usually look at me quizzically and guess that I'm either from Sheffield or Birmingham).

The heyday of the gentle British sitcom may be long past, but that does not mean the end for Su Pollard. She's still very active, doing panto each year all over the country.

O yes she is!

Su Pollard, pictured as Peggy Ollerenshaw, among Nottingham's other great heroes.

Q

QMC

The QMC (Queen's Medical Centre) is the UK's largest non-metropolitan hospital – only the Royal London is bigger, and that has only been the case since 2012. Situated directly adjacent to the very picturesque main campus of the University of Nottingham, it was the UK's first ever purpose-built teaching hospital. Each year, over 300 of the best and brightest are inducted as medical students there.

Those arriving at the main entrance may be puzzled by the odd, abstract-looking sculptures which stand on a raised grassy island just outside. Certainly, they prove quite puzzling to the people of Nottingham. They were, apparently, gifted to the

Did these fall out of a giant's ear?

hospital, anonymously. The are made of white marble and weigh approximately 10 tons. It is often said that they are supposed to represent the bones of the inner ear, but I can find no evidence of this; besides which there are only two sculptures, not three, and they look nothing like the hammer, anvil and stirrup.

Once you have successfully crossed the threshold, you are immersed in a truly bewildering warren of intense activity. The QMC is a remarkably busy place. The statistics speak for themselves: there are over 6,000 members of staff, 1,300 beds and over 2,000 people visit the hospital every day. As the major trauma centre for the East Midlands it receives almost 200,000 A&E admissions each year and the children's wards alone care for around 40,000 people per annum.

Anyone looking to visit relatives has to navigate their way around an astonishing 27 miles worth of corridors to find the correct ward. It is technically possible to run a marathon around the QMC and still not see it all.

This was also the first hospital in the country to be linked to the tram network.

With shops, cafés and its own radio station, this is a bustling, energetic place filled with people who are willing to go the extra mile to provide excellent treatment in the face of enormous pressure. The people of Nottingham are justly proud of their big, BIG hospital.

Theoretically, you could run a marathon in this building.

R

Raleigh Cycle Company

As I reflect, glumly, upon the fact that it is almost impossible for me to cycle into Nottingham and back without having to go up a massive hill, my mind is often dragged back to those carefree times when cycling was an activity of childhood leisure and not a necessary form of transportation. The rusty boneshaker that I have now will never compare with the delightful Raleigh *Bluebird* that I learned to ride on.

Raleigh is one of the great names in bicycles. Their easily recognisable 'bird head' badge truly is a seal of quality. The chopper model is now an icon of 1970s style and few of us can look back on our childhoods without fond memories of our Raleigh bikes.

The company grew from humble beginnings. In 1885, two former lace makers, Richard Morriss Woodhead and Paul Eugene Louis Angois, opened a bicycle workshop in Raleigh Street. They were later joined by another ex-colleague, William Ellis. The company remained a small one, initially turning out around three bikes per week. However, one of their creations caught the attention of the entrepreneur and inventor Sir Frank Bowden.

A sick man, Bowden had been told that he only had months to live. One doctor advised him to take up cycling as a way of improving his health. So impressed was he with his Raleigh bike that he bought the company, expanding operations and transforming Raleigh (which he named in honour of the workshop's address) into the world's largest producer of bicycles. He achieved this meteoric growth in less than a decade.

The future was bright. The company would go on to produce some of history's greatest bicycles. As an older child, I had an old Raleigh *Grifter* that my grandad had salvaged – it was sturdy, with a chunky, dependable style and I loved it!

The company's bikes would go on to win Olympic medals and they even managed to expand their output whilst simultaneously producing munitions during the Second World War.

In the twentieth century, the bike factory on Triumph Road was one of the major employers in Nottingham. So integral was it to the city's identity that Allan Sillitoe chose to have the anti-hero of his novel *Saturday Night and Sunday Morning* (see *Film*) work there.

Above left: Symbol of the 1970s – it's the Raleigh Chopper!

Above right: An assurance of quality.

It wasn't to last.

As with so many of Nottingham's (and indeed Britain's) manufacturing industries, by the turn of the twenty-first century most of the work had been moved out to the Far East. Raleigh's glory days – as far as Nottingham was concerned – were over.

Still, it is nice to think, next time you are trundling up the devil of a hill, that the Raleigh bike that you learned to ride on owed it existence to the dreams of two men in a small workshop in Nottingham.

Robin Hood

There is a sign, not too far from where I grew up, that says 'Welcome to Nottinghamshire. Robin Hood County.' This statement is enough to send certain kinds of Yorkshiremen into a state of apoplexy.

Robin Hood is a true folk hero – tales of his exploits have not come down to us in the form of refined literature (as is the case with King Arthur), but through a series of popular ballads written from the late medieval period onwards, by anonymous poets and ballad-scribbling hacks. They are disjointed, contradictory and often depict a figure that is much less gallant and heroic than Hollywood would have you believe.

One of the earliest surviving ballads, *A Lyttel Gest of Robyn Hode*, was probably composed in the middle of the fifteenth century. It tells of how Robin, and his very small band of Merry Men – Will Scarlet, Much the Miller's Son and (the apparently unironically named) Little John – travel south to Nottingham to face the dastardly Sheriff. South I hear you cry? South from where?

They came down from Barnsdale.

Which is in South Yorkshire.

Making them Yorkshiremen.

Satisfied!?

Popular legend, however, will forever associate him with Sherwood and with Nottingham Castle. One of the most famous landmarks of the city is the statue of bold Robin, which stands just outside of the castle walls. This was unveiled in 1952 and it is surrounded by other smaller vignettes, depicting characters and events from the legend.

Robin Hood has long been associated with both May Day celebrations and Morris dancing. For those hardy enough to be up before dawn on the first of May, it is one of the great neglected joys of the city to go and watch the local Morris men dance the sun up around his statue.

And now, for a personal anecdote about my own brush with the notorious outlaw.

Whilst researching a previous book (*50 Gems of Nottinghamshire*) I made a startling discovery. I was looking at a long-forgotten volume of poetry by Robert Millhouse dated 1827. One of the poems was a lengthy piece entitled *Sherwood Forest*. In the notes to the second canto was a ballad. It was entitled *Robin Hood and the Abbott of Newstede* and was written in archaic English. The poet claimed to have received the ballad from a resident of Sherwood Forest who had himself heard it recited and seen it in manuscript form. Millhouse went on to state that he had never seen it in print and was therefore rectifying the situation by giving it in full.

I have an interest in old folk ballads and, whilst no expert, I am relatively familiar with the ones that form the basis of the Robin Hood legend. I had never seen this one before. With mounting excitement, I checked in all of the usual places and could find no mention of it.

Could I have stumbled on a previously undiscovered medieval or Tudor ballad?

I got in touch with the Vaughan Williams Memorial Library at Cecil Sharpe House – home of The English Folk Dance and Song Society. They passed the text on to a Robin Hood expert, who shared it with some other boffins – none of whom had ever seen the text before – and, after a little head scratching, they were able to reveal … that it was a fake!

It was a very good fake, but a fake nonetheless – some of the language was a little too flowery for a ballad of the period and there were some historical inaccuracies concerning things that would have been obvious to a medieval or early modern author, but not to an early nineteenth-century hoaxer. This was a literary fraud of the kind perpetrated by Thomas Chatterton or James Macpherson – an attempt to pass off a modern composition as something more ancient.

Whether Millhouse wrote the ballad, or was merely the victim of the hoaxer, we will probably never know for sure. Either way, the ballad is of some merit and so, for your delight dear reader, I have added the ballad of *Robin Hood and the Abbott of Newstede* to the appendix at the back of the book.

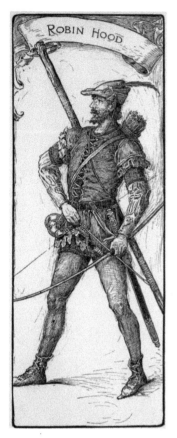

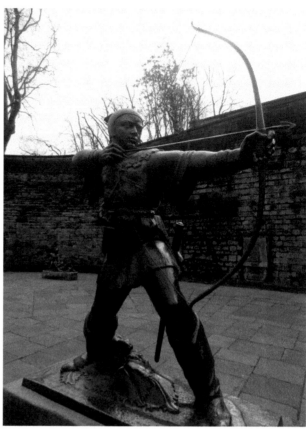

Above left: The Merry Outlaw of Sherwood.

Above right: The iconic statue, outside of the castle.

Robin fires his last arrow, beneath the castle walls.

S

Shipstone's Beer

In Basford you will find a truly phenomenal building. It dominates the urban skyline with an almost vulgar Victorian grandeur. In the nineteenth century, factories were not just the sordid, necessary evils of production. They were things of beauty. A wander along Radford Road is a case in point. The ornate carvings over the, now bricked-up, gateway and the green men that support each window would be unthinkable additions to a modern building.

It has been theorised that the green man – a face made of leaves, often seen carved in medieval churches – is an image that derives its ultimate inspiration from the Roman god Bacchus. The deity, as any passing schoolboy will tell you, is – among other things – god of winemaking. If that is the case, then they make a fitting decoration for what was, for many years, a producer of intoxicating liquors.

The origins of Shipstone's Brewery – for that is what this building once was – can be traced back to 1852, and a young(ish) man by the name of James Shipstone (1818–97). Initially, he brewed for personal use only, but such was the quality of his beer that he begun to take on staff.

A star was born.

Specifically, this was a red, five-pointed star. This was the emblem of the company, and it appeared on bottles and advertising and, in an illuminated form, upon the tower of the brewery itself. This gave the building its name – the Star Brewery.

The star even came to life, as the head of the cartoon mascot of the company: Ivor Thirst.

For almost 140 years, Shipstone's beer was brewed on the site. Seemingly, all of Nottingham's major manufactures gave up the ghost at around the turn of this century and the Star Brewery was one of the first to go. It stopped producing beer in 1990, meaning that I was far too young ever to try any. I am, however, well aware of the mixed reputation of the stuff.

Occasionally, whenever Nottingham people meet together for a sing-song, an old hymn is dusted off and given an airing. It was, apparently, written in the 1970s by a local man named 'Wocco' and it relates the catastrophic gastric effects of drinking 'Shippo's' ale, whilst parodying various patriotic songs, as well as *The Green Eye of*

Above left: The Basford skyline is still dominated by the Star Brewery.

Above right: Just one of the brewery's delightful adornments.

the *Yellow God* by J. Milton Hayes. It ends with a glorious rendition of 'There'll Always be a Shipstone's'.

And to some extent, this is true. The Star Brewery may now be office space and the home of an auctioneer, but a smaller operation does carry on the name. Since 2015, they have been brewing at the Little Star Brewery in Old Basford. They use the old logo and imply – slightly dubiously – that they have been brewing since 1852. The beer is fine and I cannot report any ill effects, outside of the usual, from drinking it.

Before we move on to something else, I think that it would be fitting to leave this article with one of Wocco's rousing choruses:

> Rule Brittania,
> And God bless Ivor Thirst,
> We'll keep drinking Shipstone's,
> 'Til we burst!

Sky Mirror

I don't know much about art, but I know what I like.

Frankly, I tend to like nature studies and the illustrations from classic children's books. Modern art (or do I mean post-modern?) always leaves me a little bit cold.

However, cold is not a word that can be used in connection with Anish Kapoor's *Sky Mirror*, a permanent sculpture situated outside of the Nottingham Playhouse. It cost £900,000 and takes the form of a large, concave, mirrored dish that reflects – as the name would suggest – the sky.

So far, so incomprehensible.

When the piece was unveiled in 2001 it caused something of a sensation. It was reported in the international press that experts from the University of Nottingham had made an alarming calculation. The mirror was not only an unfathomable white elephant – it was also a death-dealing heat-ray that could literally cook birds as they flew by.

The consultant astronomer on the project, Michael Merrifield, had worked out that for sixteen weeks of the year, around the summer solstice, the concave mirror would focus the sun's rays in such a way that they would form an intense beam of concentrated heat. 'Any pigeons which fly through the beam,' he told the papers, 'could be instantly barbecued.' Not only that, but the intensity of the beam would be sufficient – according to Merrifield – to blind members of the public.

Boffins floated the idea of using specially constructed screens to block out the sun during the deadly period and, as far has I know, neither death nor blindness has ensued from the sculpture's instillation.

In fact, two decades on, people seem to have taken quite a shine (no pun intended) to the thing. It has been on tour to the Brighton Pavilion and Kensington Gardens and copies of it are to be seen in Russia and the Netherlands. There is even a version situated at the Rockefeller Centre in New York. Predictably, this copy has been made on a giant scale, reflecting (pun very much intended) a prominent feature of the American psyche.

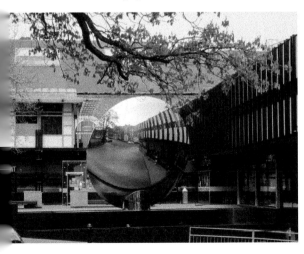

Above left: The Sky Mirror – safely viewed from behind.

Above right: Viewed from the front – watch out for death rays!

St Anne's Allotments

It's a strange feeling that one gets when walking along the winding lanes of St Anne's Allotments. The ramshackle buildings and rambling hedgerows that surround you are proof enough that you are in the heart of the country, but a quick glance at the tower blocks that dominate the skyline are enough to destroy the illusion. Here is a little slice of pastoral heaven amidst the less than divine urban sprawl.

These allotments have the great renown of being both the largest and oldest town gardens in Great Britain. People have been using this space – once known as Hungerhills – in one way or another for more than six centuries. Whether rented out as grazing land in the early seventeenth century or as recreational garden plots in the early nineteenth, they have been serving the needs of the people of Nottingham since the medieval times.

Today, they are Grade II listed and, as well as housing hundreds of plots, they provide a host of services to people from the local community.

St Anne's is an area with a rather colourful past. In the early years of this century the area's troubles were such that that they were reported in the national press. Things have come a long way since then and Ecoworks – a charity group that is based and the allotments – is evidence of the real positive steps that the community is making. They provide local people with an opportunity to connect with the natural world. This is done through construction works (there is now a beautiful straw-bale building on the site), cookery workshops, basket making workshops and, of course, gardening.

A visit to the allotments – there are regular open days – provides a wonderful opportunity to see the people of St Anne's coming together to create something genuinely beautiful. Let us hope that this enchanting space will still be serving the needs of the city's residents six centuries from now.

The Community Orchard at St Anne's Allotments. (Photo by Clem Rutter of Rochester, Kent)

Trent Bridge

I can honestly say that I do not really understand cricket. That does not, however, prevent a day out at Trent Bridge from being a thoroughly enjoyable one.

It is, as far as I understand it, one of the great cricket grounds. It takes its name not, as one would expect, from the nearby bridge, which crosses the River Trent, but from the adjacent public house. In 1838, the Trent Bridge Inn stood outside of the city. The landlady of the house happened to be married to William Clark, who was captain of the county cricket team. He arranged for his team to make use of an area of land at the rear of the building.

The early games were decidedly low key, but attendances slowly increased and permanent structures were built. By 1899 the ground was hosting its first test match – England v. Australia. Should you be interested, the result was Australia: 252 & 208/d; England: 193 & 155/7.

My wife assures me that this means that Australia won.

From what I can make out, it was 2-0.

Today, it is the home of the Nottinghamshire County Cricket Club and regularly hosts Test Matches, One Day Internationals and Twenty20 matches. For those of us not of a sporting bent, it is, on a sunny day, a delightful spot to sit and drink beer whilst having a picnic.

Closed for Covid – the home of Nottinghamshire Cricket.

TRENT BRIDGE
EST. 1838

HOME OF NOTTINGHAMSHIRE
COUNTY CRICKET CLUB

Left: The pub where it all started.

Below: The Trent Bridge Inn, pictured under leaden skies!

Occasionally, the fun is dampened by the thwack of leather upon willow or the intrusion of the club's mascot – Nuts the red squirrel – whom I suspect to be a man dressed up, as all the other local squirrels are grey. This should not, however, detract from the enjoyment of the day, much of which can be derived from watching the crowd and assessing whether anyone else has the foggiest what's going on.

TV

The 1980s were, in many ways, a golden age for Nottingham. Brian Clough was leading Nottingham Forest to ever greater heights, Torvill and Dean were skating their way to glory and Central Television – based at Lenton Lane – was creating some of the finest television programmes ever to grace our screens.

The studios began filming in the autumn of 1983 and for over twenty years they created light, fluffy confections that would delight the nation. From *Bullseye* to *Family Fortunes, The Upper Hand* to *Emu's Pink Windmill*, twenty-four carat TV gold was being mined in Nottingham. Outside of the studios, some programmes – such as *Boon*, staring Michael Elphick and the children's classic *Woof* – made the most of the city's locations as a backdrop. Many people in the city still have anecdotes about the times that they appeared as extras or had run-ins with the stars.

Of course, the greatest of all of these televisual treats was *Auf Wiedersehen, Pet* which, whilst being largely set abroad and featuring central characters from every region of England apart from the East Midlands, relied heavily of location shots, filmed in and around Nottingham.

Sadly, facing stiff competition from satellite broadcasters, the studios were closed in 2005 and the building now belongs to the University of Nottingham.

Central Television's finest creation.

UNESCO City of Literature

Lord Byron, D. H. Lawrence and Alan Sillitoe. These are just three of the great literary figures whose works have contributed to Nottingham being selected as a UNESCO city of literature. In this honour it is joined by such notorious Meccas of the written word as Wonju, Obidos and Norwich.

The award was made in the December of 2015, amongst much rejoicing and hopes that it would be a major boost to the local economy. Could this be a way of encouraging tourists and students into the city?

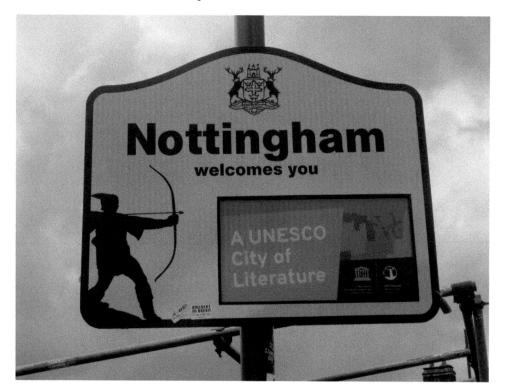

A city with a literary bent.

Above left: D. H. Lawrence – one of Nottinghamshire's men of letters ...

Above right: ... though often misunderstood in his own lifetime.

UNESCO's centre of operations for Nottingham are at Bromley House Library, which has, for over two centuries, been a quiet base for Nottingham's literary and thinking community. It is home to nearly 50,000 books, many of which are by local authors. Fittingly, Allan Sillitoe's personal collection is housed there, having been donated by his widow.

Outside of the rarefied atmosphere of the library, the city has a large and lively literary scene, with a number of poetry groups, storytelling groups and even a kind of author's community centre – the Nottingham Writers' Studio – which runs a series of courses and workshops for aspiring wielders of the pen.

Unicorn

For what it's worth, I think that no visitor to Nottingham should miss out on seeing the unicorn at St Mary's Church in the Lace Market. The medieval building is surely the finest in the whole city, but it is the small, gaudily painted statue that keeps me returning again and again. It stands, alongside its partner in crime – a golden lion (see *Lions*) – at the end of the aisle, by the main doors.

The two creatures are heraldic symbols of the United Kingdom. The lion represents England and the unicorn Scotland. This may strike many people as odd, as the lion is not indigenous to our islands and the unicorn is, sadly, extinct in all but the remotest areas of the Highlands.

Nottingham's unicorn is a gloriously camp fellow. His mane, horn, hoofs and the tip of his tail are all gold, as is the chain that hangs from a crown around his neck.

This colour contrasts with the alabaster white of his fur, the black of his doe eyes and the blood red of his lips. One fetlock supports a shield, upon which can be seen three crowns and a green wooden cross. The cross is obviously made of very roughly trimmed boughs as the stumps of branches can still be seen.

The emblem on this shield is the heraldic crest of Nottingham.

The two statues were created in around 1705 and, for over 300 years, they have been shuffled around the church. Doubtlessly, they have brought delight to generations of worshippers and visitors as they have made their perambulations. Even burglars have found them a great source of amusement. In 1765, the church was broken into and money was stolen. Stealing money from a church is a pretty contemptible thing to do, but I can't help being tickled by the fact that the thieves took the time to dress up the two beasts in the clergyman's surplices.

I rather think it would have suited them.

And so the statues wait, down through the long centuries, for their plum cake and the sound of drums.

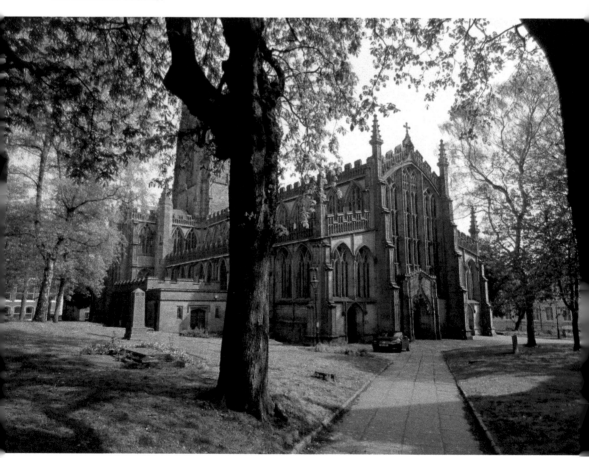

St Mary's Church – careful, here be unicorns.

Victoria Station

I don't use the phrase 'hideous carbuncle' lightly, but it is hard to find other words to sum up the Intu Victoria Centre. The shopping centre is a post-war blight that afflicts all major towns and cities across the developed world, but this one is particularly objectionable as it occupies the site of what was the Nottingham Victoria railway station.

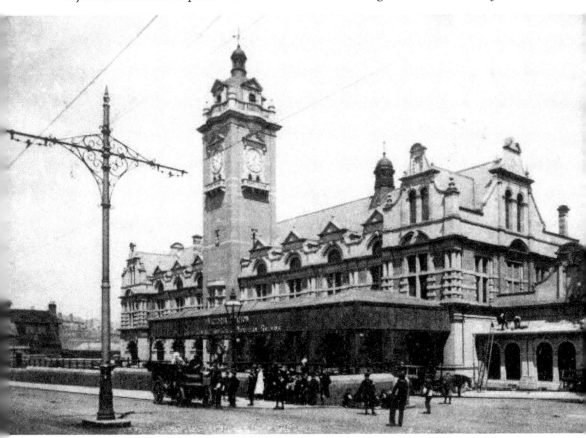

A cathedral of steam – Victoria Station.

All that remains of the former edifice is a solitary clock tower. It stands, looking as bereaved as a building can, at the main entrance to the centre. On one of its walls is a little plaque marking the fiftieth anniversary of the station's closure in 1967, and telling of the glories that once surrounded it.

Opened in 1900, the Victoria Station was a triumph of late Victorian architecture. The vast building was constructed, in the red brick that is a hallmark of the city, in an imposing, Renaissance style. Old photographs show a vast, bustling space – this was the last of the grand cathedrals to the glories of the age of steam.

It was, of course, a major feat of engineering – its construction required the demolition of whole streets in the heart of the city. Homes, pubs, schools, churches

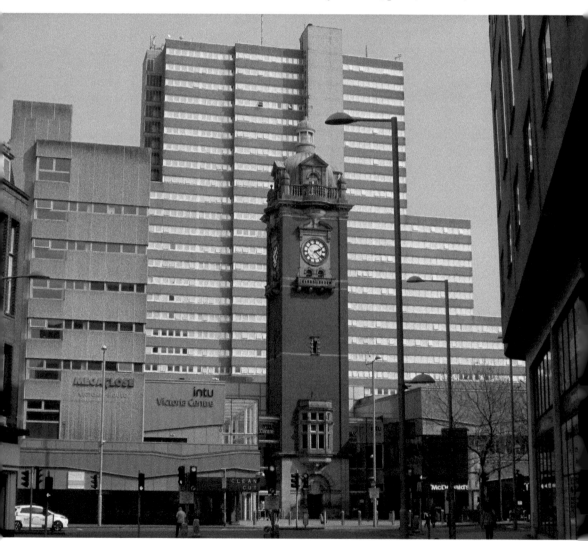

The clock tower still survives as part of the Victoria Shopping Centre.

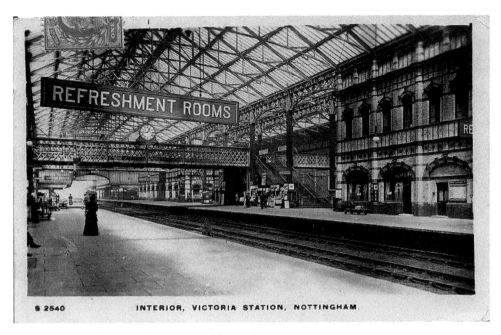

S 2540 INTERIOR, VICTORIA STATION, NOTTINGHAM.

An old postcard showing the interior of the station.

and even a workhouse were all removed to make way for the huge structure, which was built on a 13-acre site. In all, 6,000 people were displaced and had to be rehoused.

For six decades steam locomotives rumbled past the two long platforms. Porters rushed hither and thither. Hackney carriages delivered and collected passengers. Inside, tearooms and bedrooms catered for travellers in need of a respite from their journey.

This was not to last.

As in so many other places, Doctor Beeching and the rise of the motor car did for the grand station. Traffic declined to a trickle and it officially closed on 4 September 1967. Against a great deal of public protest it was soon demolished – all but for the forlorn-looking clock tower – and the Victoria Centre took its place.

I am too young ever to have known the railway station, and I acknowledge the huge human cost of its construction, but I still cannot help but feel that the city lost something wonderful in its demolition and were given something rather sub par in return.

Weekday Cross

Outside the Nottingham Contemporary art gallery, by a main road, along which trams and buses hurtle in an endless stream, there stands a pillar on top of several low steps. This is the Weekday Cross, and it (or rather a version of it) has stood here for longer than anyone can find trace of.

Long, long ago, prior to the arrival of the Normans, this was the centre of the Saxon settlement of Snottingham. Here, a bustling market sold various foodstuffs. There was a church and a meeting hall (Moot Hall). This truly was the heart of the town.

The inscription at the foot of Weekday Cross.

Come 1066 and all that, the invaders had arrived. The Norman settlement was clustered around the castle and what is now the opposite side of the city. The market at Weekday Cross was survived, but economic forces began to drive trade towards a place that was convenient for both communities. A new, larger marketplace (now the Old Market Square) was created at the point where the Norman and Saxon settlements met.

Weekday Cross had lost its primacy, but it continued as a working market, selling a variety of produce throughout the week, for centuries to come.

It has long been the custom to have a cross erected in a marketplace, and records show that there has been one on the site since at least 1529, although there had probably been one there for a long time prior to that. The cross was finally pulled down in 1804 and much of the area was later redeveloped to make way for the railway.

In 1993, the Nottingham Civic Society erected the current 'cross' (it doesn't actually have any arms, so I think it is technically a pillar) and it now stands as a reminder of a very remote past, in a very modern setting.

Once the heart of the Saxon settlement – Weekday Cross.

Xylophone Man

As stated in the introduction, this book is part of a series dealing with things of local interest in cities across the country. As part of the brief, authors have to write at least one article dealing with every single letter of the alphabet. I pity those poor fools from other places, who have to desperately struggle to come up with an entry for X. For Nottingham, the solution is easy; in fact, the book wouldn't be complete without it! Allow me to introduce you to our very own superhero … Xylophone Man!

For much of the 1990s, a familiar, white-bearded figure provided the soundtrack to the city. He sat, day after day, outside what was then C&A, and tinkled randomly on his multicoloured, child's metallophone. His name was Frank Robinson, although nobody knew that. The people of Nottingham, unable to correctly identify percussion instruments, christened him Xylophone Man and that is what he became, cheering the hearts of young and old alike with his inoffensive, tuneless music.

When Frank died in 2004 the city went into mourning. As a mark of respect, a simple memorial – a slab with his name and a picture of his xylophone on it – was laid in his familiar pitch.

Here's to you Frank, for the joy that you brought to us all and for having a nickname that began with an X.

Xylophone Man's memorial slab.

Y

Ye Flying Horse Inn

Ye Flying Horse Inn first came to my attention when, as a teenager, I read the (now largely discredited) book *The Monocled Mutineer*. It was in this pub, on 11 November 1918, that the notorious criminal Percy Toplis was arrested.

Strangely, given its great age, this seems to be one of the few things of interest that ever happened in Ye Flying Horse. The only other notable event in the pub's long history seems to have occurred in 1813. In that auspicious year, the pub was the venue for a grand dinner, held to celebrate Britain's (false) victory over Napoleon. Outside, in the Old Market Square, an effigy of the Corsican burned among scenes of much rejoicing.

An ancient pub that is sadly no more.

The most beautiful pub that I never drank in.

Aside from that, the city centre hostelry has had a long, quiet existence.

The inn was first established in 1483 – making it one of the four ancient pubs in the city centre, alongside The Bell, The Salutation and The Trip to Jerusalem (see *Nottingham Pubs*). It served under various different names (it was once the more prosaically titled Traveller's Inn) and in varying states of repair and degradation. The fine frontage that can be seen today is of, relatively, modern design, despite its appearance.

Ye Flying Horse closed down in 1989, when I was far too young to even be aware of it. It seems a great shame that a pub of this antiquity, located in the very heart of the city, couldn't make a going of things.

Surely it could have been a tourist attraction?

All that really remains of the pub now is that beautiful frontage. The building now houses a number of shops, accessed through Flying Horse Walk. These are all of a kind – original artwork, craft beer, posh cheeses and high-end fashion.

Personally, I'd rather have a pint of Shippo's and a bag of crisps.

Z

Zulu

Childhood visits to Nottingham Castle were a mixed experience. The museum of the Sherwood Foresters Regiment, contained therein, was the home of a boy-eating monster. It came in the form of a mannequin wearing a First World War gas mask. The mask comprised of an elephant man-style bag with dead, circular glass eyes and an insect-like breathing tube. My chest still tightens at the thought of it.

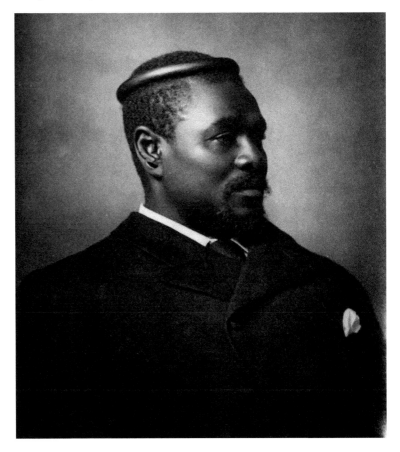

The King of the Zulus.

Scarring as this experience undoubtedly was, it was made worthwhile by the treasure that was housed just around the corner – a genuine Zulu shield! It belonged, according to the label, to King Cetshwayo.

So, who was this mysterious king with an unpronounceable name?

Cetshwayo was, of course, the king of the Zulus; in fact, he was the last king of the Zulus (or certainly the last to rule over an independent Zulu nation). A mountain of a man – standing at around 6 feet 7 inches and weighing (according to some reports) approximately 25 stone – he led his men to an astounding series of victories over British forces before being defeated at the Battle of Rorke's Drift. Inevitably, he could not prevail over the might of the British Empire and he was deposed and sent into exile. However, his intelligence, dignity and gentle manner endeared him to the world and garnered a great deal of sympathy for both himself and his people.

The world is now probably most familiar with Cetshwayo's history through the 1964 film *Zulu*, in which the great king was played by his own real-life great-grandson, Mangosuthu Buthelezi.

The manner in which his shield (along with his sceptre and assegai spear) came into the hands of the Sherwood Foresters, and thence found their way to Nottingham Castle, is open to debate, but the six-year-old version of me was eternally grateful that it did.

Appendix
Songs and Ballads of Nottingham

'Ned Ludd's Triumph' – trad. *c.* 1812

Chant no more your old rhymes about bold Robin Hood,
His feats I but little admire
I will sing the Achievements of General Ludd
Now the Hero of Nottinghamshire
Brave Ludd was to measures of violence unused
Till his sufferings became so severe
That at last to defend his own Interest he rous'd
And for the great work did prepare

Now by force unsubdued, and by threats undismay'd
Death itself can't his ardour repress
The presence of Armies can't make him afraid
Nor impede his career of success
Whilst the news of his conquests is spread far and near
How his Enemies take the alarm
His courage, his fortitude, strikes them with fear
For they dread his Omnipotent Arm!

The guilty may fear, but no vengeance he aims
At the honest man's life or Estate
His wrath is entirely confined to wide frames
And to those that old prices abate
These Engines of mischief were sentenced to die
By unanimous vote of the Trade
And Ludd who can all opposition defy
Was the grand Executioner made

And when in the work of destruction employed
He himself to no method confines
By fire, and by water he gets them destroyed
For the Elements aid his designs
Whether guarded by Soldiers along the Highway
Or closely secured in the room

He shivers them up both by night and by day
And nothing can soften their doom
He may censure great Ludd's disrespect for the Laws
Who ne'er for a moment reflects
That foul Imposition alone was the cause
Which produced these unhappy effects
Let the haughty no longer the humble oppress
Then shall Ludd sheath his conquering Sword
His grievances instantly meet with redress
Then peace will be quickly restored

Let the wise and the great lend their aid and advice
Nor e'er their assistance withdraw
Till full fashioned work at the old fashion'd price
Is established by Custom and Law
Then the Trade when this ardorus contest is o'er
Shall raise in full splendor it's head
And colting, and cutting, and squaring no more
Shall deprive honest workmen of bread.

'Fair Nottingham Town' – trad. Kentucky, USA. Collected in 1910 by Josiah Combs

As I went down to Nottamon fair
I rode a stone horse, they called the gray mare;
She had a green down list her back:
And there wasn't a hair but what was coal black.

She stood still, but she threw me in the mud
She daubed my hide and bruised my shirt,
From saddle to stirrup I mounted her again,
And on my ten toes rode over the plain.

I met the king and the queen and a company more
A-riding behind and walking before,
And a stark naked drummer a-beating his drum,
*With his heels in his *** a-marching along.*

I asked them the way to fair Nottamon town,
They were so mad not a soul look-ed down-
They were so mad not a soul look-ed down
To tell me the way to fair Nottamon town.[a]

When I got there, no one could I see,
They all stood around a-looking at me;

I called for a quart to drive gladness away,
To stifle the dust – it had rained the whole day.

I sat on a cold hot frozen stone,
Ten thousand standing 'round me, yet I was alone;
Ten thousand got drownded before they were born,
I took my hat in my hand to keep my head warm.

Then I'll take my black horse and a-fishing I'll go,
A-fishing I'll go, whether or no;
My fish they turned over, my wagon did spill –
I'll sell my gray mare – I'll be damned if I will!

The first girl I have, it shall be a boy,
Returned to the house of my first joy;
The first house I live in, it shall be a hog-pen,
And what-in-the-hell will become of me then?

Robin Hood and the Abbott of Newstede – possibly Robert Millhouse, *c.* 1827

As Robin Hood, a spring morning,
Fared forth with his bow alone,
By the Well of the Harte he was aware
Alle of a rufulle moan.

Then Robin turned him round to spy
Wherefrom the wail mote be,
And he behelde, uppon the grounde,
An unseemly sighte to se.

A palmer poore, with tearfulle eies-
His haire, white as the spray
That crests the torrent as it flies,
On its peturbed way.

Then straightway Robin did inquire,
Why hee was in that guise;
For he was naked on the moore,
And moaned in weary wise.

'A palmer am I, poor and olde,
And bare as ye may se;
And I have alsoe lost my harpe,
I ever bore with me.

'Last nighte, I called at Newstede Abbay,
A boon, a boon to crave,
But the fat monks and friars alle,
Noe boon wold let me have.

'Sayd I, Syth ye are God's almoners,
And holde the poore man his fee,
And syth ye are God's stewardes alle,
Why give you not to me?

'Then one did looke so fierce and woode,
As hee wolde looke me through;
And my olde harpe, that was in myne hand,
Hee reaved him unto.

'Then bad me take myselfe awaye,
Fast as my leggs wold speede,
Or they wold teach me speedylye,
Better their wordes to heede.

* * * * * *

'With a large stone, that was therbye,
I brast the Abbay dore,
And oute againe, they rushed on me,
With boisterous loude uprore.

'Then did the Abbot give commande,
My cloke of palmer's grey,
By the soure monks that rounde hime stoode,
Shold quick bee torne away.

'And in the mere, the Abbay therebye,
Alle naked as ye se,
Thewile the monks did plunge me in,
Hee laugh'd righte merriley.

'The Abbot is of stature lowe,
But rounde enow for five;
A jollier wight is not on grounde,
Nor knave like him alive.

'I from them rushed, and hither came,
With alle the speede I may;
Much fearing, that the bitter colde

Wold end me ere the day.'
Robin he held an arrowe in hand,
And he shooke it angrily,
And by the point of his arrowe swore,
Avenged he shold bee.

Then putting his horn untoe his mouth,
He blew blasts three,
And from the greenwoode his merry men
Came tripping over the lee.

And Robin spake unto Little John,
'In clothe of Lincolne greene,
Arraye this Palmer, poor and olde,
Who vilely used hath beene.'

Then oute the harper Robin bespake,
'My minstrelle thou shalte bee,
And thou shalt make us musick swete
Under the greenwoode tree.'

And than sayd he, in merry wise,
'The Abbot's shaven crowne
Shal taste the coldnesse of the lake
And ere the sun goe downe.

'And thou shalt have thy harp againe,
The bodye of God me speede,
And hee that hath misused thee soe
Shall rue his cruelle deede.'

Now Robin is gone to Newstede Abbay,
In Palmer's cloke of grey;
And he is feasting with the fryers,
As blythe as the birds in May.

And jolly Robin doth eate fulle well,
And onn every thing woll dine;
And hee will taste their venison,
And drinke their blude red wine.

And much the monks his mood admire,
Soe fulle of joke is hee,
With teares of laughter in their eyne
To see him make so free.

And after he hath had his will
On alle thinges in his way,
He draweth forth his little horne,
Fulle loudly for to playe.

And three loude blasts he merily blewe,
And hee blew with might and main,
Untille it rung through Newstede woode
Where laye his merry train.

'What fellow art thou?' the Abbot cried,
And he frowned in angry moode;
Sayd he, "Thou art of the greene forreste,
The outlaw Robin Hood."

'Where is the Harper?' quoth Robin then,
'That craved an alms of thee?
Him surely hast thou reaved of life,
By him who dyde on a tree.

'For bye the wall his harpe doth hange,
His scallop likewise, and cloke;'
Then in rushed Robin Hood's merry men alle
Thewhile these wordes he spoke.

And on the lordlye Abbot they seize,
Who pale doth turn, and quake,
And ever the Palmer doth attende
To plunge him in the lake.

Loude was the laughter and the jest,
That runge through Newstede woode;
And evermore enjoyed the joke
The Palmer and Robin Hood.

And now around the greenwoode fire
On the Abbot's meats they dine;
And the minstrelle doth sing the merry jeste,
While they drinke the Abbot's wine.